POSTCARD HISTORY SERIES

Findlay

IN VINTAGE POSTCARDS

POSTCARD HISTORY SERIES

Findlay

IN VINTAGE POSTCARDS

Eric Van Renterghem

ARCADIA
PUBLISHING

Published by Arcadia Publishing
Charleston SC, Chicago IL, Portsmouth NH, San Francisco CA

Printed in the United States of America

Library of Congress Catalog Card Number: 2001095420

For all general information contact Arcadia Publishing at:
Telephone 843-853-2070
Fax 843-853-0044
E-mail sales@arcadiapublishing.com
For customer service and orders:
Toll-Free 1-888-313-2665

Visit us on the Internet at www.arcadiapublishing.com

To my wife Jane who has always supported my dreams. To my children, Craig, Brynn, and Kevin, who allowed me to start and finish this project. Especially to those teachers who nurtured my love of writing and fired my passion for the exploration of history. To my parents Don and Marlene, my first and foremost teachers. The hunger for knowledge is my constant companion.

CONTENTS

ACKNOWLEDGMENTS

Findlay: The Story of a Community
William D. Humphrey
1961

History of Hancock County
Jacob Spaythe
1903

Across the Years in Findlay and Hancock County
R.L. Heminger
1963

Findlay Business and Industrial Historical Outline
Don E. Smith
1981

A Pictorial History of Findlay
Paulette J. Wiser Richard Kern
1999

Postcards from the collections of:
Mr. Gary McMillen & Eric Van Renterghem

INTRODUCTION

Since the last half of the twentieth century, letter writing has become a lost art. With the introduction of inventions such as the telegraph and telephone, people became less interested in the time-consuming handwritten letter. In the late 1800s the only direct way to communicate personally was through letter writing. Family members wrote each other informing of news and gossip of their families and neighbors. Sometimes, when extra cash was available, photographs were added for a more complete package of communication.

However, with the advent of new and inexpensive photographic technology, a new form of communication came about. The ability to transfer images to paper became accessible. No longer were images regulated to the glass daguerreotypes or tin types, which were fragile and costly to produce. Images could be copied onto inexpensive paper. This new form of communication became the latest rage. For the first time you could jot down a few well-written lines and send it to a friend or loved one. The major difference was that this time it had a photograph on the front! For a mere cent you could impress someone with a view of where you were staying or places you had visited. Yes, we are talking about postcards, those little 3-by-5 inch glossy cards with interesting views.

Postcards are European in origin and took several years before they become accepted in America. In 1869 a Hungarian doctor, Emanuel Herrmann, suggested using a small postal card for business and government communications. It wasn't until 1873 in the United States, when in Chicago the Inter-State Industrial Exposition utilized postal cards sent out as advertising to promote the show to the rest of the country, that post cards became a new way to communicate in a brief style. However, these first postcards were regulated by the government and only allowed writing on the front and the inscription, "Private Mailing Card" to be printed on the other side.

The Golden Age of the postcard as we know it begins in the United States in 1907. For the first time the words "Post Card" were printed on the undivided backs. This allowed for the address and written communication to be placed on the same side while allowing for designs to be placed on the front. During the years of 1901–07 millions of postcards were produced. Many of the postcards used in America during this time were produced in European countries such as Germany.

Categories of the postcard history are divided in these main areas: Undivided Backs, 1901–07; Divided Backs, 1907–15; Early Modern Era with white borders, 1916–30; Linen

Cards, 1930–45; and the Photochrome, 1939–present. The subject areas in postcards are further divided into other categories. View cards, the most popular, offer images of popular buildings, streets, and stores. Greeting cards are just that—a form of greeting for a holiday, birthday, or featuring a religious passage. Historical cards were produced to show images of buildings destroyed, wars, expositions, and political happenings. Art cards contained artist-designed drawings and sketches. These were used for social comments such as wars and presidential elections or just plain homegrown humor.

The areas of concentration of the cards in this book will be the Photographic, Photochrome, Linen, and Early Modern Era. The years we travel will take us from around 1905 to 1960. In the course of researching the quantities of Findlay-Hancock County postcards, I found the numbers to be astonishing. Between two advanced collectors and my modest collection, the number of different postcards depicting this area hovers around 1,000! As you can envision, the task of selecting the right representational postcard becomes mind boggling. Hopefully these some 200 images will be representative of the postcard era of Findlay and Hancock County, Ohio. Sit back, relax, and travel with me through some of the best and worst times of Findlay's history through the eyes of the postcard.

One

UPTOWN, DOWNTOWN, AND ALL AROUND THE TOWN

*T*his first chapter featuring the Downtown was part of the catalyst for writing this book. With all cities
and villages, large and small, the central business district was and is, for most towns, the areas most
widely photographed for the subject of postcards. Having been directly involved with our Downtown with
civic activities and having exposure with the federal, state, and local historic preservation societies, I see the
need for the continued education of those who truly comprehend the act of preservation, and those who possess
little knowledge of it.

The loss of any building in a Downtown can be devastating. Loss of revenue generated through sales,
employment, and taxes will slowly erode any Downtown. Some of these images are of buildings lost by the
all-too-familiar wrecking ball, fires, and unsympathetic remodeling. These views will give insight to the
architecture that was popular during the heyday of Downtown prior to urban sprawl.

Downtowns are the first and sometimes last impressions seen by visitors. Local pride, as well as the
display of monetary power, is built into all Downtowns. The largest and the smallest buildings give the
visitor a show of architecture from the mighty Richardson Romanesque to the adaptable and compelling,
folksy, vernacular styles of Italianate and Greek Revival.

Most commercial districts started with the government buildings in the town square followed by growth,
like that of a tree with rings, of buildings surrounding the nucleus, the courthouse. Follow the path of the
postcards and see how much has been lost and how much has been saved!

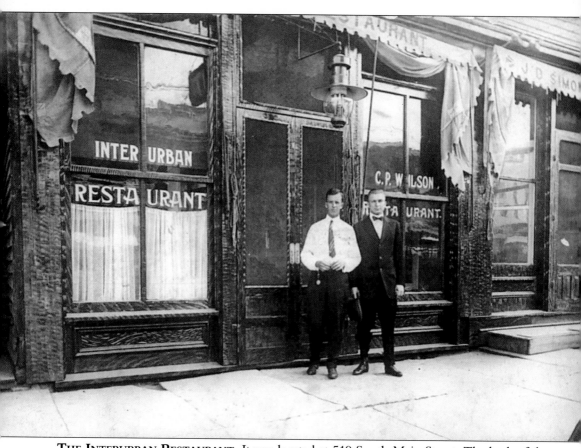

THE INTERURBAN RESTAURANT. It was located at 519 South Main Street. The back of the card reads, "Restaurant I worked at while in Findlay." 1915 vintage.

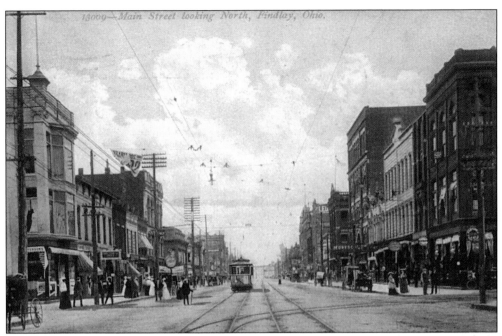

LOOKING NORTH FROM THE INTERSECTION OF SANDUSKY AND SOUTH MAIN STREET. Notice that there are no automobiles and everyone appears to be "posing." 1908 vintage.

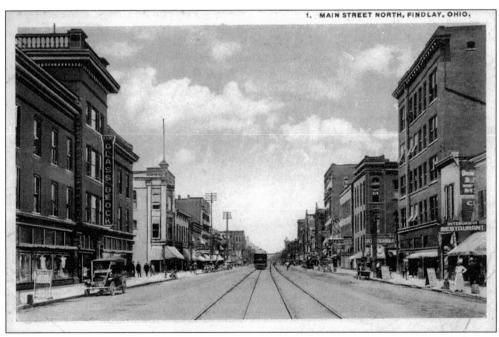

LOOKING NORTH FROM HARDIN AND SOUTH MAIN STREETS. Here, automobiles are evident. Notice the vendors who are set up on the sides. 1915 vintage.

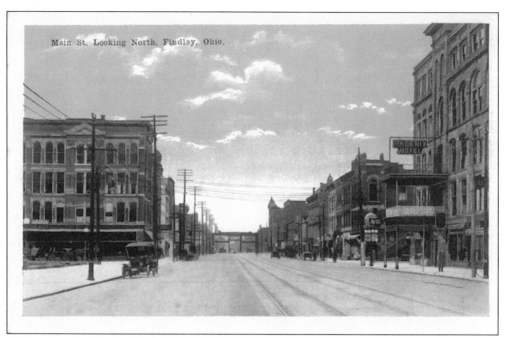

An Image From the Front Of the Courthouse. Look at all of the overhead wires!

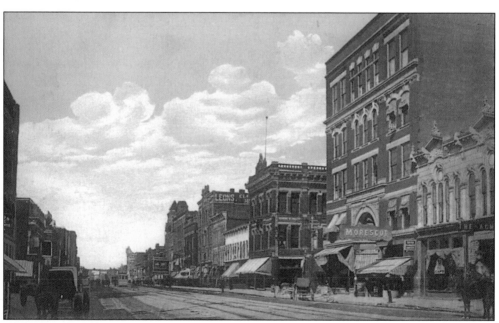

The Central Business Portion. This is the 400 block of South Main Street. This card was printed in Germany. 1907 vintage.

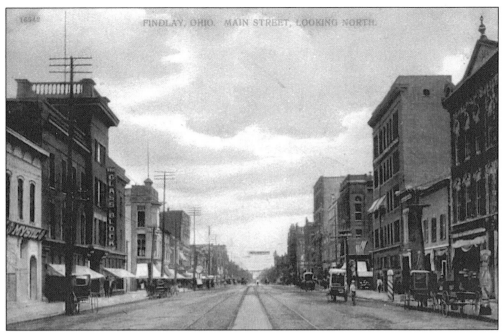

ANOTHER BEAUTIFUL GERMAN-MADE POSTCARD. The Mystic Theater is visible. The postcard reads, "Heat wave.. 98 degrees today!" 1908 vintage.

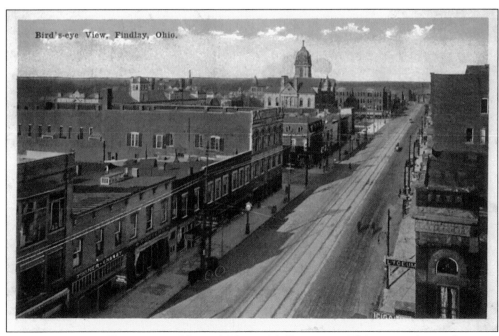

IMAGE FROM THE TOP OF THE NILES (MOREY'S) BUILDING. This was perhaps taken on a Sunday, because there is no trolley and only a few people pictured. 1917 vintage.

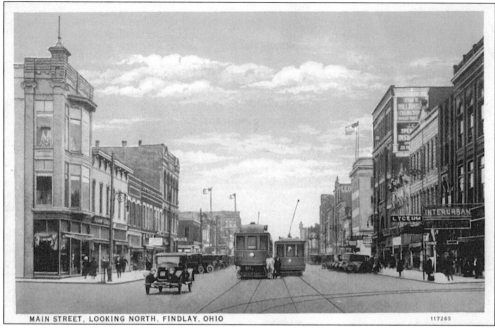

MAIN STREET, LOOKING NORTH, FINDLAY, OHIO 117265

Look at All the Flags Flying! Notice the drivers of the two Interurbans posing. 1914 vintage.

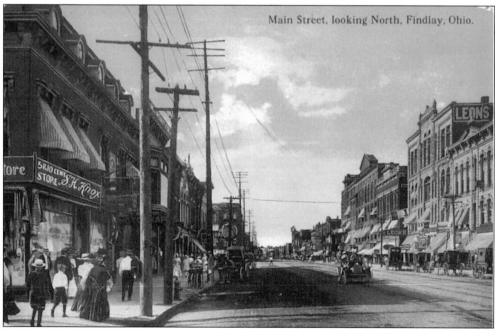

Main Street, looking North, Findlay, Ohio.

Image From the West Corner of Crawford Street. This looks like mostly carriages and everyone is dressed up. It was important to dress properly when downtown.

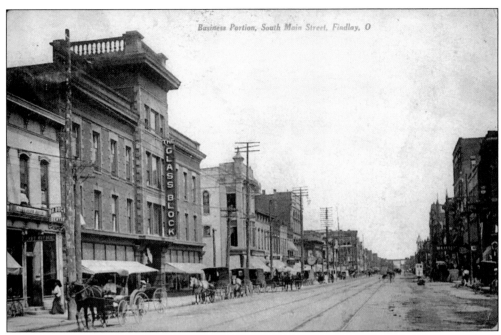

POSTCARD READS, "DOES THIS LOOK NATIONAL TO YOU?...NO RIDING IN AUTOS...RAINED FOR TWO STRAIGHT DAYS." 1909 vintage.

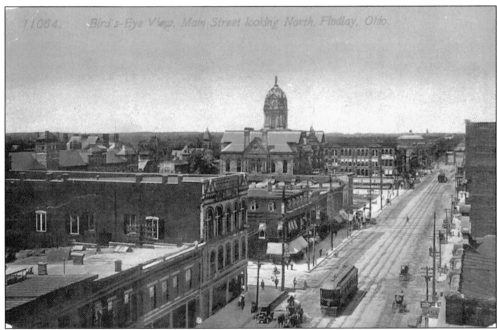

AN UNUSUAL IMAGE OF THE ROOFTOPS. This was taken from the rooftop of the Frey Block on the corner of East Sandusky and South Main. The team of horses pulls the water wagon used to keep the dust down. 1913 vintage.

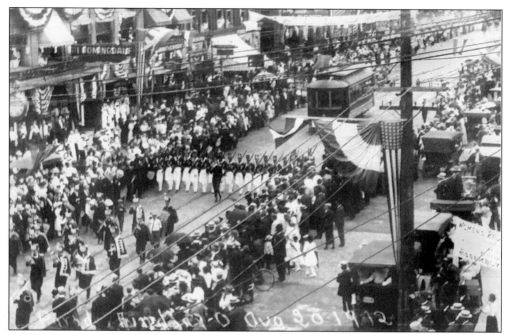

A Wonderful Image of Findlay's 1912 Centennial Celebration. This photo was possibly taken by a photographer on a ladder or up a lamppost in front of the courthouse.

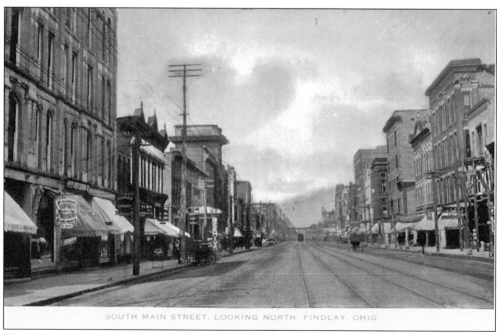

SOUTH MAIN STREET, LOOKING NORTH, FINDLAY, OHIO

The Intersection of Hardin and South Main Street. 1911 vintage.

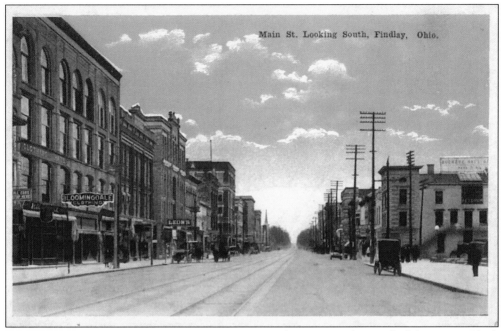

Main St. Looking South, Findlay, Ohio.

LOOKING SOUTH FROM MAIN CROSS STREET. The sign on the roof of the Davis Block reads, "Buckeye National Bank pays 3%." 1920 vintage.

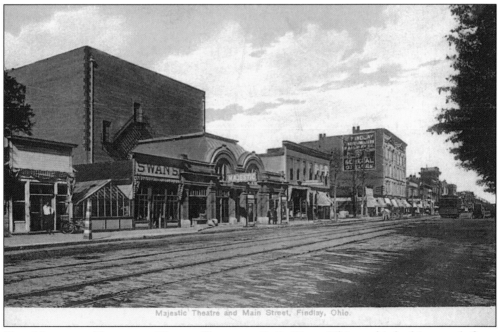

Majestic Theatre and Main Street, Findlay, Ohio.

THE MAJESTIC, THEN THE HARRIS THEATER, IS IN VIEW. This card is looking north from Lincoln Street. 1919 vintage.

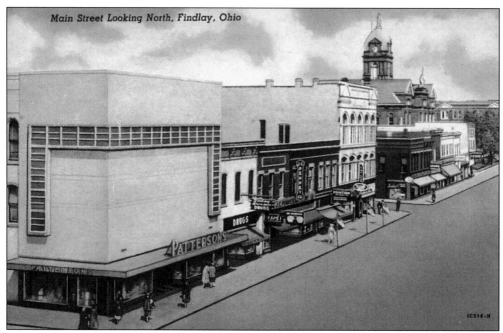

A Card Printed By the Findlay News Agency. This is a modern Findlay. 1951 vintage.

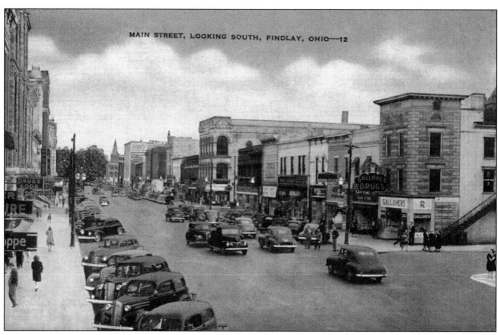

The Caption on the Back Reads, "Findlay, the Ideal City." 1949 vintage.

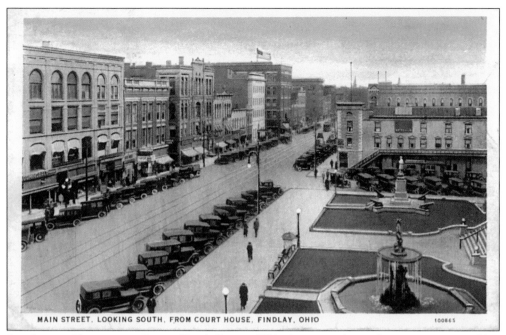

AN IMAGE FROM THE OHIO (SKY) BANK. This is a very busy downtown, no parking available! 1928 vintage.

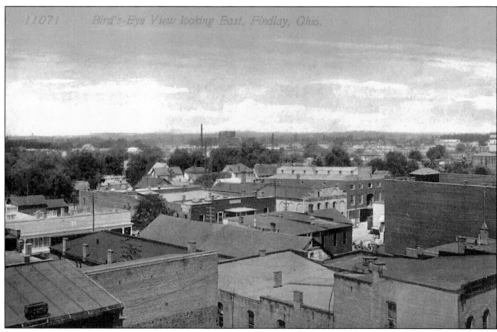

Bird's-Eye View looking East, Findlay, Ohio.

ANOTHER ROOFTOP IMAGE FROM THE NILES BUILDING. The Krantz Brewery is in the distance and a gabled roof house appears to be being moved down Crawford Street. 1911 vintage.

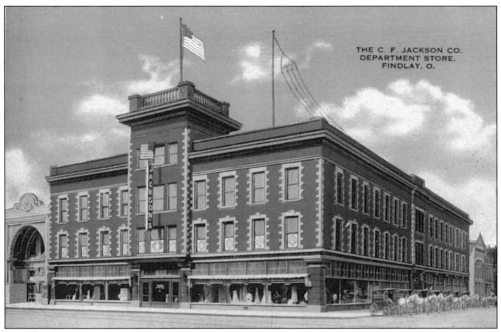

THE FAMOUS JOY HOUSE-JACKSON'S DEPARTMENT STORE. This was a truly unusual and magnificent store in its heyday.

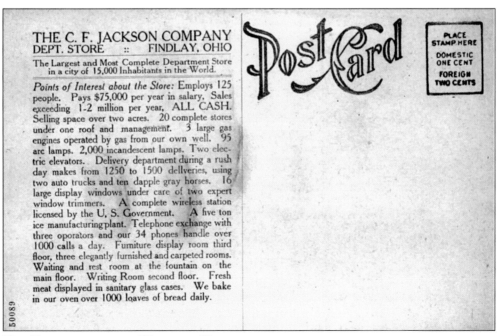

THE REAR OF THE CARD WITH THE DESCRIPTION.

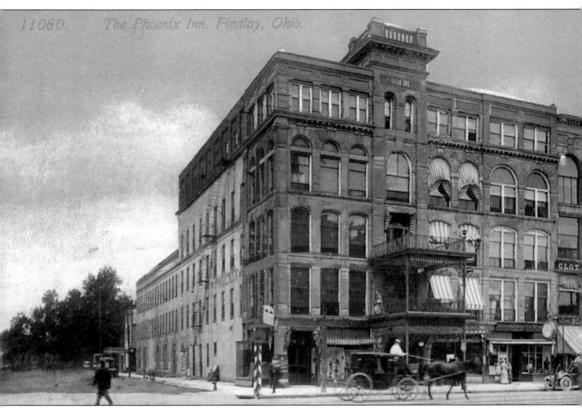

THE HUMPHREY-PHOENIX INN. The Humphrey-Phoenix Inn was a luxurious hotel that was razed in the mid 1970s. During its early years, hunters from all over came here to stay while pheasant hunting. Rumors circulated that Clark Gable was spending some time in this hotel. 1915 vintage.

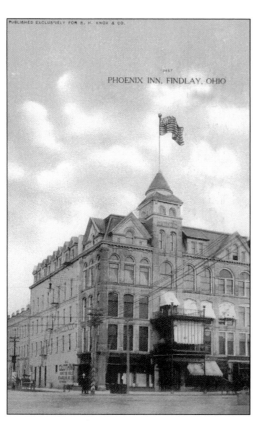

PHOENIX INN, FINDLAY, OHIO

EARLIER VIEW OF THE INN. Notice the conical rooftop, which was replaced after the fire in 1909. 1907 vintage.

A LATER IMAGE OF THE PHOENIX AFTER THE FIRE IN 1909.

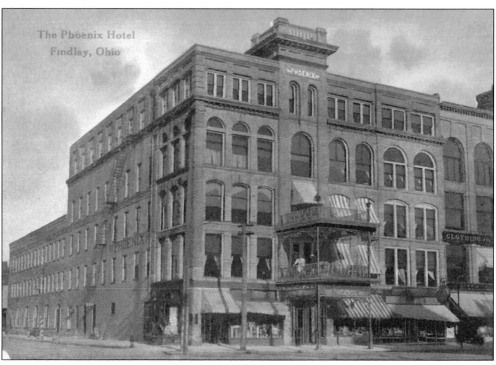

The Phoenix Hotel
Findlay, Ohio

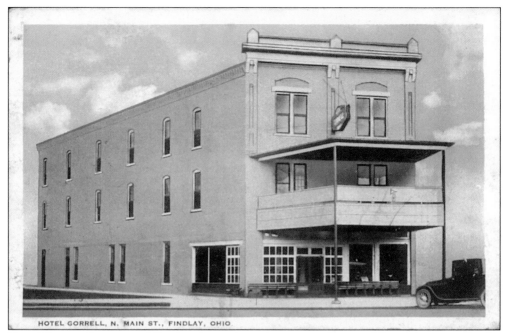

HOTEL GORRELL, N. MAIN ST., FINDLAY, OHIO

THE HOTEL GORRELL. The hotel was later known as the Franklin and eventually the Northview and was a frequented by the many transients who used the railroad. It had 85 rooms, cost $1.00 and up, and used the European (shared bathrooms) plan. The back reads, "Located on the Famous Dixie Highway." 1920 vintage.

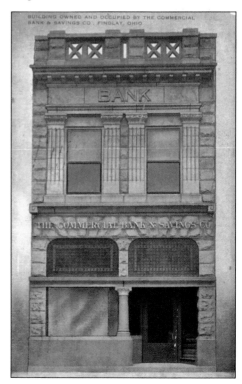

THE COMMERCIAL BANK AND SAVINGS, 335 SOUTH MAIN STREET. Located north of the former First National Bank, this spot is now a parking lot. 1909 vintage.

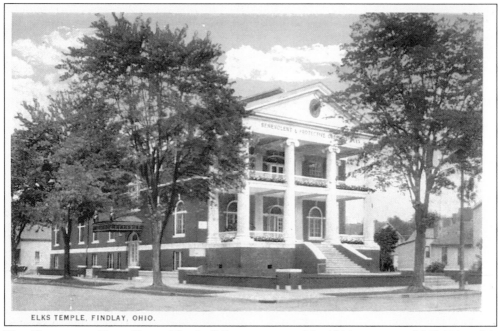

ELKS TEMPLE, FINDLAY, OHIO.

THE BEAUTIFUL ELKS CLUB. The building was erected in 1916 at a cost of $60,000 and is considered to be one of the finest in the state of Ohio.

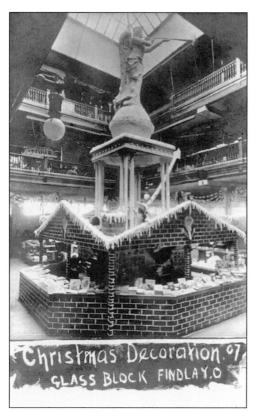

Christmas Decoration. 07
GLASS BLOCK FINDLAY.O

A RARE INTERIOR VIEW OF THE GLASS BLOCK. "Meet me at the fountain" was a popular phrase used in the early 1900s. This wonderful department store was a forerunner to the malls with its many different departments inside. 1907 vintage.

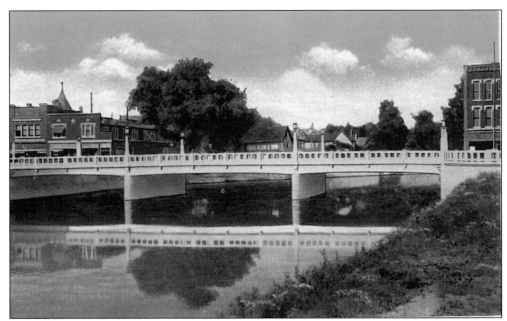

THE MAIN STREET BRIDGE. This concrete bridge replaced the old iron bridge that stood for over 50 years. It was completed in 1934 at the cost of $113,00, and later replaced in 1999 at an estimated $1 million!

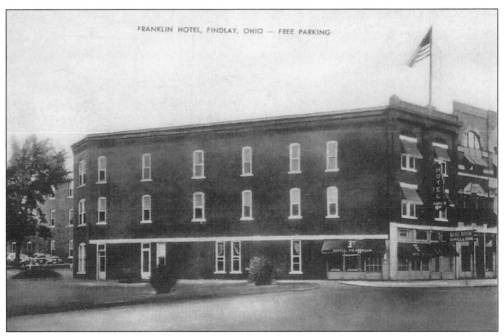

FRANKLIN HOTEL, FINDLAY, OHIO — FREE PARKING

ANOTHER OWNER FOR THE GORRELL. In this card, it is now the Franklin with rooms rising in price to $3 and up! 1935 vintage.

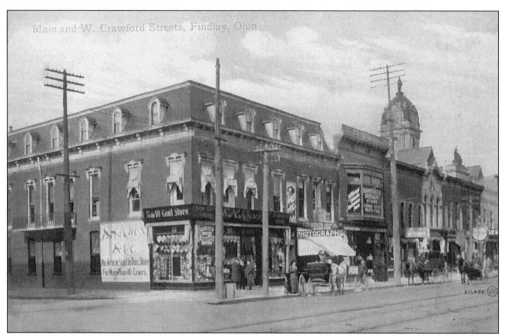

THE KNOX FIVE AND DIME. This store stood on the west side of Crawford and South Main Streets. It remained a dime store until it was razed in the 1960s. 1910 vintage.

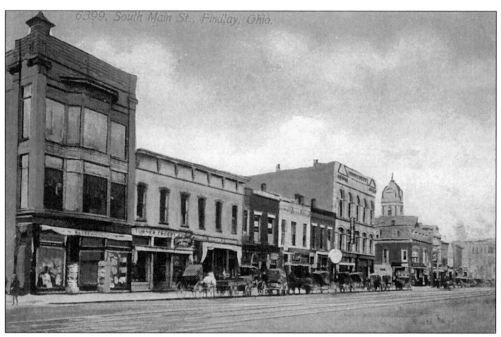

THE 400 BLOCK OF SOUTH MAIN FACING WEST. Patterson's Department store occupied that corner for over 80 years. The Patterson family owned it from 1849 to the 1980s; it eventually ran out of heirs and was donated to the University, which sold it.

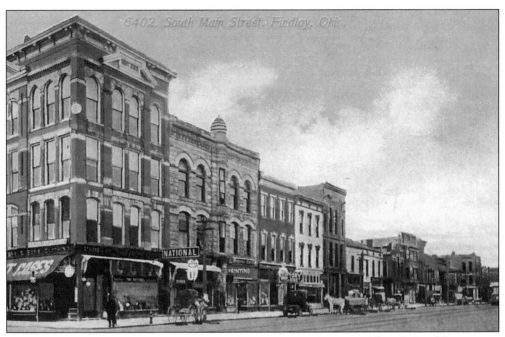

THE CORNER OF WEST MAIN CROSS AND SOUTH MAIN STREETS. The National Store was a fixture on this corner for many years. Later Ohio Bank purchased it, and it remains a banking center today. A few stores to the right is the Victory Theater. Notice the large molar hanging on the dentist sign.

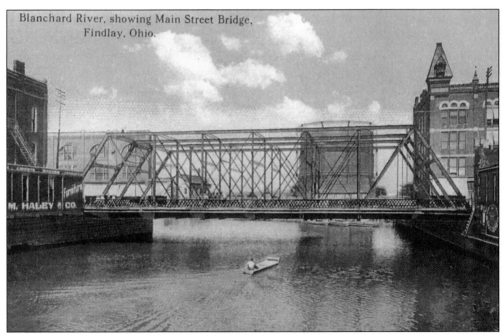

Blanchard River, showing Main Street Bridge, Findlay, Ohio.

A VIEW OF THE BLANCHARD LOOKING EAST. The iron bridge is dwarfed by the huge storage tank looming in the background. The beautiful Riverside Block is also visible. 1912 vintage.

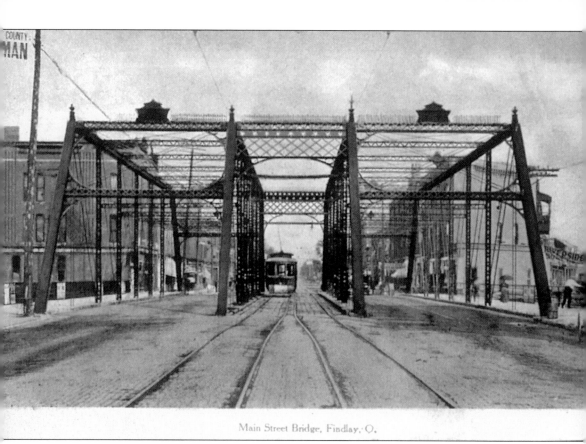

Main Street Bridge, Findlay, O.

THE UNIQUE MAIN STREET IRON BRIDGE WITH THE CENTER FOR THE INTERURBAN. To the right is a banner advertising rides to Riverside Park. 1911 vintage.

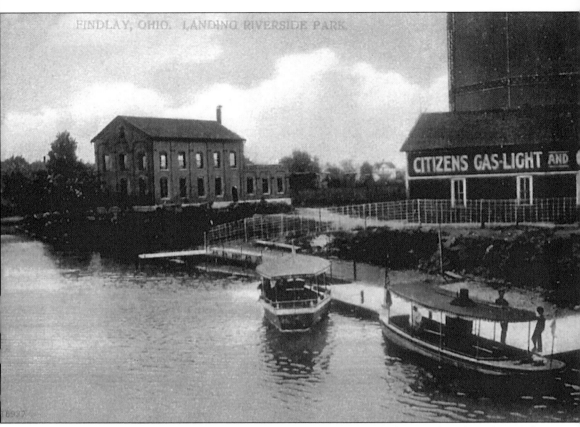

ONE OF THE BOAT DOCKS FOR EXCURSION TO THE PARK. The large tank to the right was for the artificial gas company. At one time there were over 10 boats that provided transportation; however, competition from the automobiles and taxis cut in on profits and many boats lost money. Most of them moved on to other locations in the state. 1910 vintage

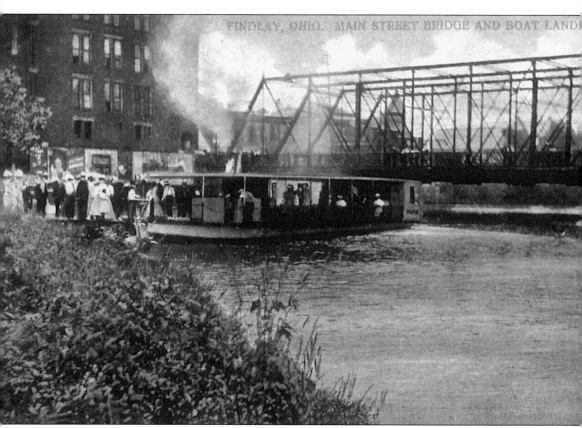

THE *PASTIME* DOCK. The dock west of the iron bridge was for the *Pastime*, the famous steamer that was owned by the Haley family. It boasted having an organ on board for passengers' listening pleasure on the way to the park.

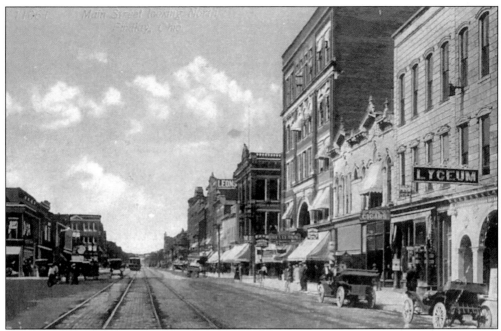

THE VIEW LOOKING NORTH WAS VERY POPULAR. This was taken at the intersection of Crawford and South Main Streets. 1915 vintage.

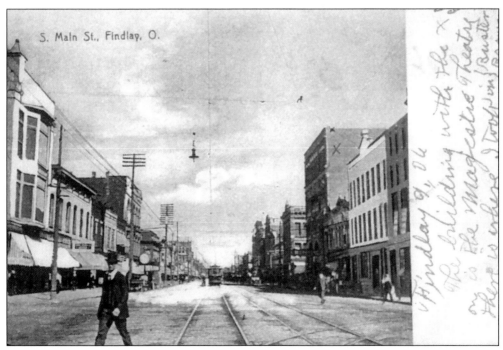

NORTH AGAIN FROM SANDUSKY AND SOUTH MAIN. The card reads, "The building with the X is Majestic Theater. There is where I took in Buster Brown." 1906 vintage.

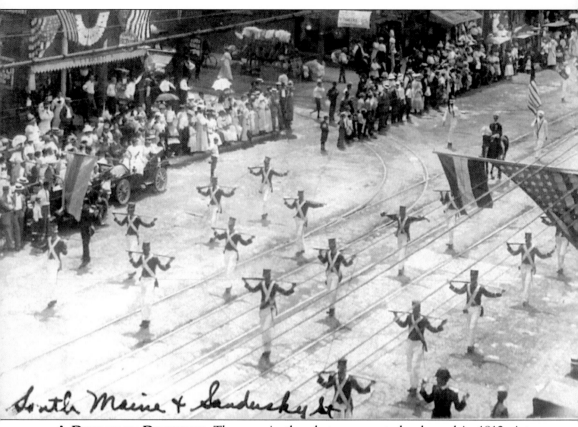

A DISPLAY OF DISCIPLINE. The men in the photo appear to be dressed in 1812 vintage. uniforms. It was taken during the 1912 Centennial Celebration, facing east on the corners of Sandusky and South Main. If you were lucky you could enjoy the activities from your automobile. 1912 vintage.

Two

HOMES AND
NEIGHBORHOODS

*T*ime has been kind to Findlay—that is to say that the majority of the beautiful homes built during and
after the Gas and Oil Boom survived. Sadly, many of the earlier homes predating the era of gas and oil
wealth have been lost. Some were moved and remodeled while others were razed and replaced with newer
homes. When Ohio Oil began to expand and grow, the East Sandusky and East Street homes were torn
down to make room for the up and coming automobile and the dreaded parking lots needed to corral them
for the employers.

When the boom began in 1884, many speculators became wealthy overnight. Land was bought and sold
several times before it was ever recorded at the courthouse. Wealth brings on the need to show thy neighbor
how much you can spend! The land just south of the commercial district on South Main Street was pasture
land with a few houses here and there. Suddenly prices for lots began to bring thousands of dollars and
architects sharpened their pencils and began to design some wonderful vernacular 19th century houses.
Fortunately, many homes were passed down to younger generations and many were able to sustain their
wealth and maintain these huge houses. The growth continues today and these golden homes of yesteryear
still sparkle and captivate tourists as well as long-time citizens.

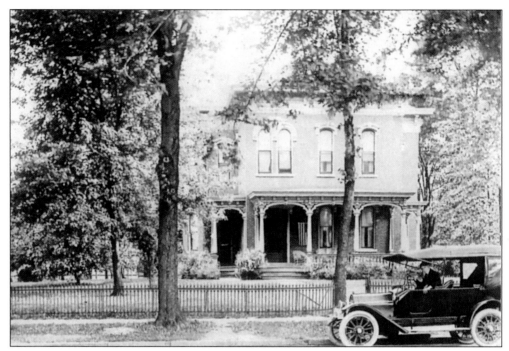

THE BEAUTIFUL ITALIANATE HOME OF JACOB BURKET. With his home located at 521 West Sandusky St., Jacob was a prominent lawyer and later a chief justice in the State of Ohio Supreme Court. The home occupies two lots and was landscaped with lush trees. It was a doctors' office for many years but later restored by the Ryan family in the 1980's. The man posing in the car could be a Burket. 1910 vintage.

THE TREE-LINED STREET OF EAST LIMA. The residential areas appear to be well designed with wide sidewalks and fine landscaping. The sender told the receiver that it took 7 hours to travel from Toledo to Sidney, a distance of about 110 miles! 1912 vintage.

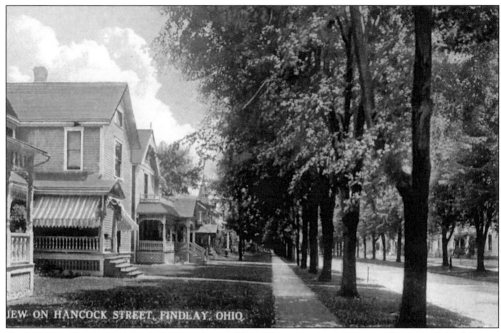

COLORFUL AWNINGS GRACED MANY OF THE HOMES ON HANCOCK STREET. Maple trees lined these streets. 1911 vintage.

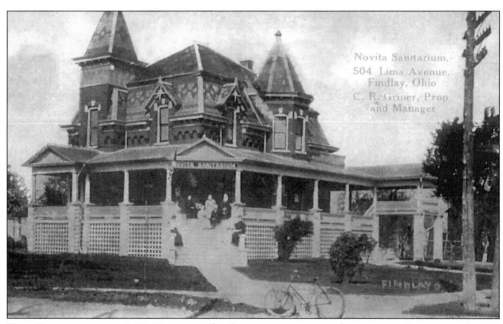

Novita Sanitarium,
504 Lima Avenue,
Findlay, Ohio
C. R. Griner, Prop
and Manager

THE RESIDENCE OF A.H. BALSEY. This home was converted to a sanitarium around 1905 and was torn down in the 1960s for the Kirkpatrick funeral home. 1909 vintage.

A SECTION OF HARDIN STREET. 1914 vintage.

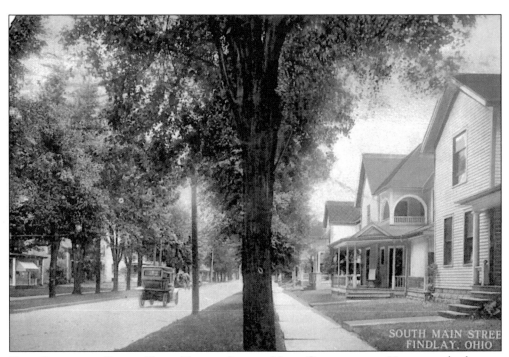

THIS POSTCARD READS THAT THIS IS SOUTH MAIN RESIDENTIAL. However, the houses appear too small and the road isn't nearly wide enough. 1912 vintage.

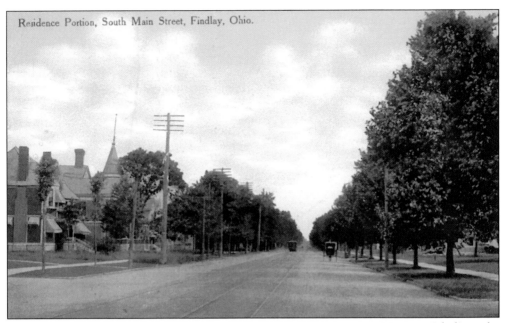

Residence Portion, South Main Street, Findlay, Ohio.

A LONG SHOT OF SOUTH MAIN STREET LOOKING APPARENTLY NORTH. I believe the home on the left to be the Kimmel home at 1034 S. Main Street. 1910 vintage.

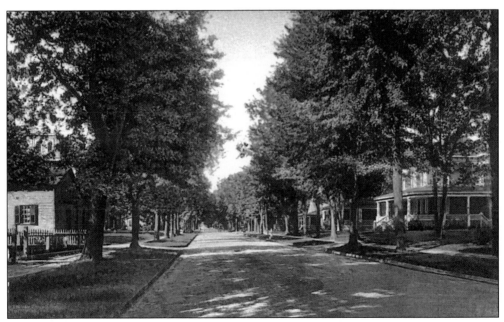

THE BRICK STREET OF WEST SANDUSKY IN THE 400 BLOCK. Once named Back Street, many of these homes predate the gas and oil boom. The Hull House (Museum) is visible on the right. 1909 vintage.

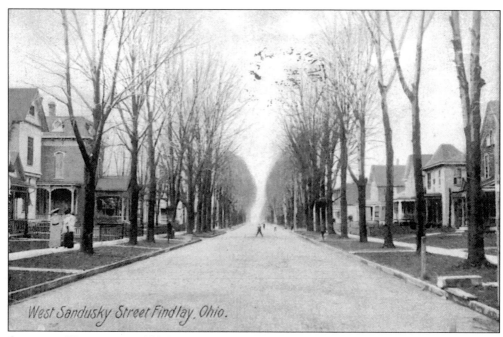

ANOTHER VIEW OF THE 300 BLOCK OF WEST SANDUSKY STREET. Notice the boys posing in the middle of the road. 1907 vintage.

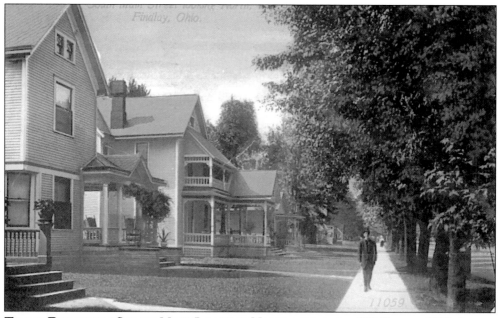

THIS IS DEFINITELY SOUTH MAIN LOOKING NORTH FROM THE 800 BLOCK. 1915 vintage.

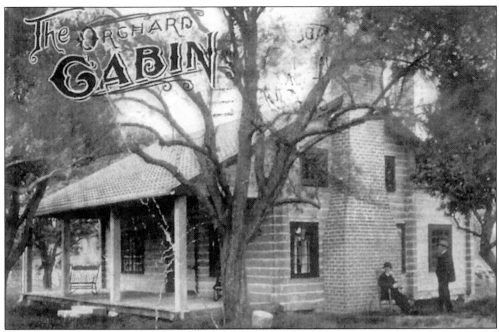

THE ORCHARD CABIN OF DR. TRITCH. Dr. Tritch lived at 859 South Main but fancied a quieter atmosphere at times. The side advertising appears to be selling cigars. 1907 vintage.

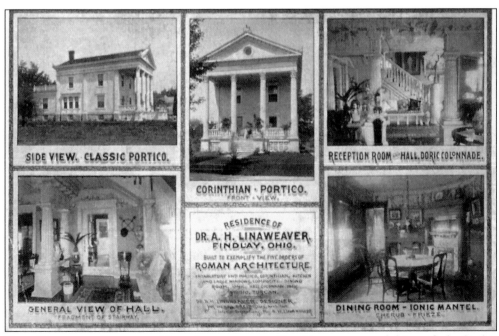

SIDE VIEW. CLASSIC PORTICO.

RECEPTION ROOM — HALL. DORIC COLONNADE.

CORINTHIAN · PORTICO.
FRONT · VIEW.

GENERAL VIEW OF HALL.
FRAGMENT OF STAIRWAY.

RESIDENCE OF
DR. A. H. LINAWEAVER,
FINDLAY, OHIO.
BUILT TO EXEMPLIFY THE FIVE ORDERS OF
ROMAN ARCHITECTURE

DINING ROOM — IONIC MANTEL.
CHERUB · FRIEZE.

THE HOME OF DR. AND MRS. LINAWEAVER. Dr. Linaweaver and his wife built this Neoclassical revival home at the turn of the century. Both husband and wife excelled in artistic endeavors. The doctor painted with oil and his wife decorated porcelain. The home utilized the five orders of Roman architecture: Ionic, Tuscan, Corinthian, Doric, and Composite.

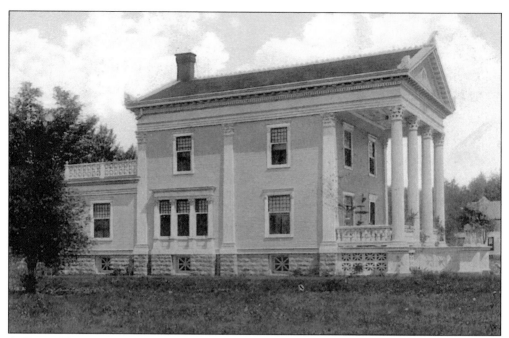

A Hand-Tinted Postcard of the Linaweaver Home. The postcard advertised, "Urine and Sputum examined for $1.00 each!" 1907 vintage.

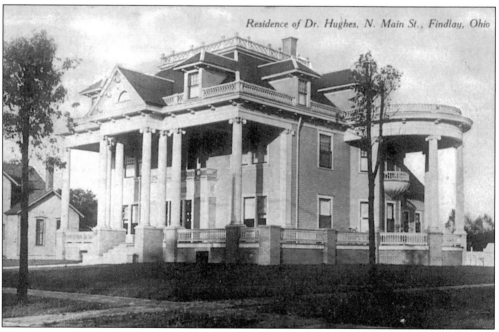

Residence of Dr. Hughes, N. Main St., Findlay, Ohio

The Hughes Home. Not to be outdone by Dr. Linaweaver, Dr. Hughes built his version of a Neoclassical style home on North Main St., north of Washington School. 1911 vintage.

Three

THE COURTHOUSE

*T*he courthouse was Findlay's first real grand government building. Many towns are laid out with the courthouse as the centerpiece of their community. In the case of Hancock County, this present courthouse was the third installment in courthouse history. The first two were outgrown and replaced with a magnificent example of Neoclassical architecture. With the enormous amount of growth during the 1880s, due to the gas and oil boom, the citizens believed that a first class courthouse was in order. What started out in 1885 to be an estimated $305,000-building ended up costing around $500,000, with interest, in 1888. The stonework, granite columns, elaborate stained glass, and monumental walnut doors give any visitor the vision of prosperity. The courthouse was the place to be for speeches and legal business or just to stretch out on the lawn or a bench by the beautiful fountains. This courthouse is a permanent monument to all who have passed this way and to those generations coming of age to appreciate all of its splendor and grace.

As expected, postcards were published over a time span of 50 years. Some were black and white, while others were hand tinted or finished in Photochrome. If you look closely you see subtle changes in landscaping with monuments and extensive fountains. In 1998–99 the Courthouse went through a much needed $3 million restoration.

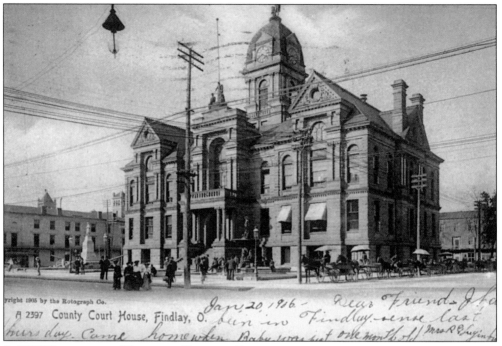

A 1905 VIEW OF THE HANCOCK COUNTY COURTHOUSE.

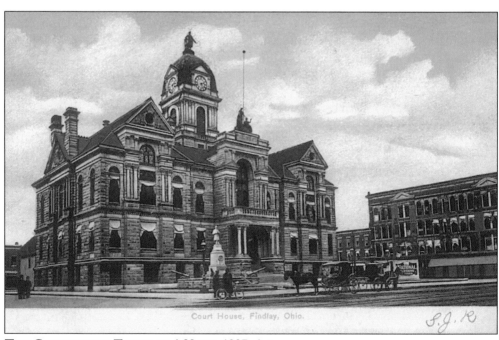

THE COURTHOUSE TAKEN AT 4:09 PM. 1907 vintage.

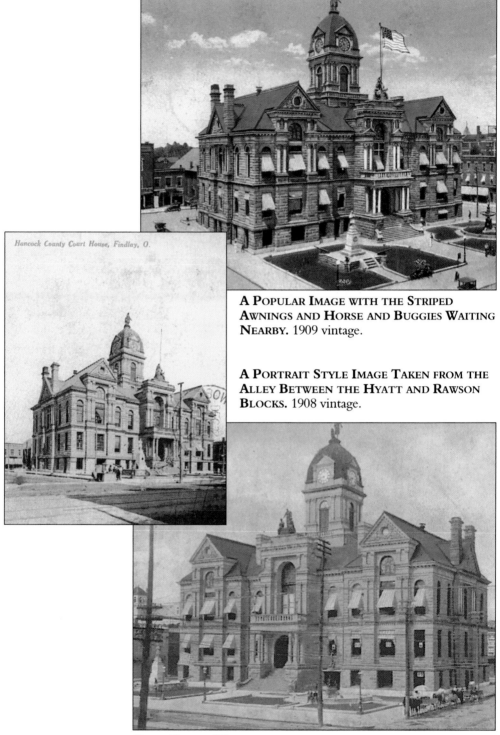

Hancock County Court House, Findlay, O.

A POPULAR IMAGE WITH THE STRIPED AWNINGS AND HORSE AND BUGGIES WAITING NEARBY. 1909 vintage.

A PORTRAIT STYLE IMAGE TAKEN FROM THE ALLEY BETWEEN THE HYATT AND RAWSON BLOCKS. 1908 vintage.

CARD READS, "ELECTRICAL STORM LAST NIGHT . . . HAD A GREAT TURKEY DINNER." 1915 vintage.

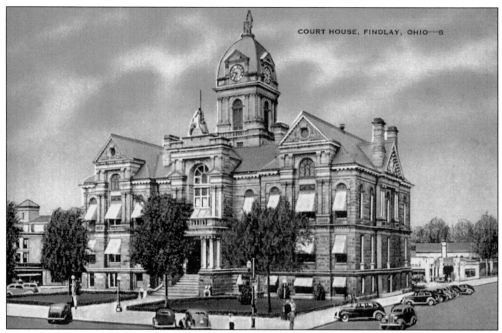

A Modern View with Diagonal Parked Autos. Notice the trees, and the fountains and memorial are no longer present. 1950 vintage.

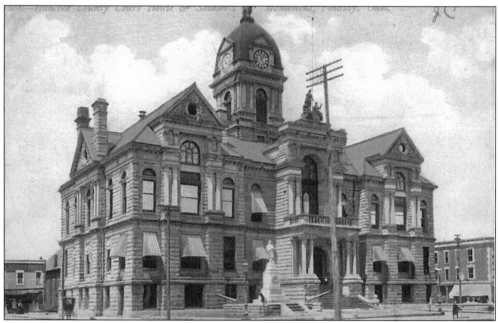

A Ground Level View. This was probably taken on a Sunday, judging by the scant activity. 1908 vintage.

44

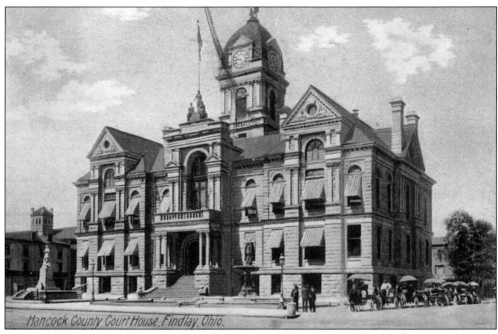

THE POPULAR VERSION. This is another version of the popular card, but a little different with the horses and the drivers with umbrellas cooling off nearby.

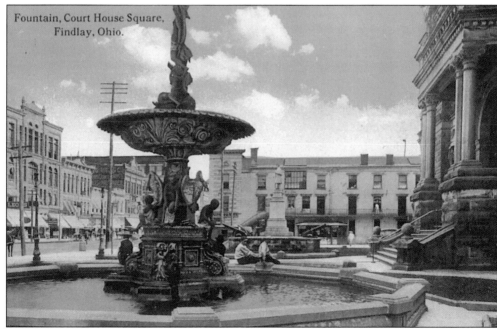

A BEAUTIFUL SHOT OF THE FOUNTAIN ON THE NORTH LAWN. A boy and his father cool off nearby, with a good view of the Rawson Block across the street. The large glass window in the background in the Davis Block was the photography studio of A. Ketchum. 1914 vintage.

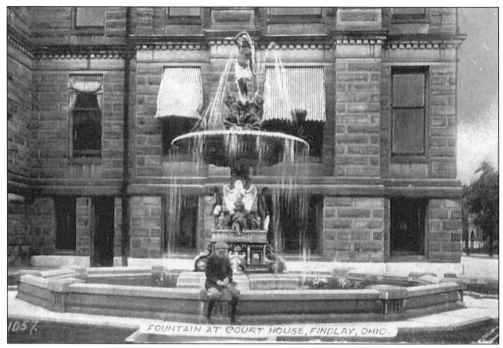

FOUNTAIN SHOT. The same fountain with a front view, with the lad probably counting the pennies he snuck from the fountain! 1916 vintage.

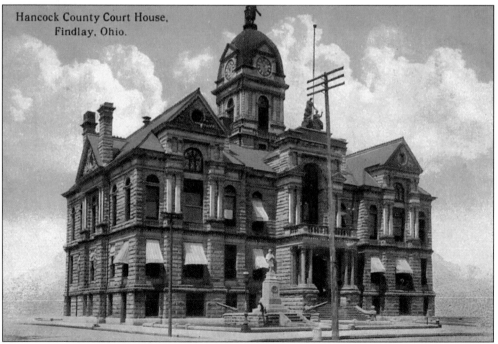

OKAY, IT LOOKS SIMILAR BUT IT'S DIFFERENT! The background has been covered up, giving more prominence to the Courthouse. 1912 vintage.

Four

ENDURING ENTERTAINMENT AND RIVERSIDE PARK

*A*hh…*hear the sounds of a child giggling as the carousel continues to whirl the horses through yet another imaginary race. Next, perhaps a stop at the soda fountain for an ice-cold treat of soda or ice cream, which was housed in a wooden framed building surrounded by a serpentine brick wall. These images come alive for me as I remember the beauty and excitement Riverside Park had to offer Findlay and Hancock County.*

City parks were familiar places to have family outings, reunions, and picnics. Back in 1904, Riverside Park became a reality. The land was owned by the city and had a reservoir, which could double as a swimming pool, and a soothing dam near the icehouse. Large maples and sycamores arched over the area with the Blanchard River flowing behind this land of enchantment! It was a time of change as agricultural occupations compromised less than 50 percent of the jobs in Hancock County. Shopkeepers, merchants, and other skilled craftsmen flourished, thus beginning a new era of having extra income for pleasure and entertainment.

Excursions to parks were already popular with trains going to Cedar Point, Lakeside, and Put-In-Bay. Trains ran to Findlay daily and the Pastime, *the popular steamer that would carry passengers from downtown to Riverside Park, carried thousands of travelers annually to the summer Chautauqua and The House of Mirth and other park attractions.*

The Five Columbians, with famous Marilyn Miller, and other popular entertainers kept people coming back every summer. Moving pictures, miniature bowling, a shooting gallery, and other games lined the sidewalks embossed with the names of local merchants. A carousel as well as a modest roller coaster graced the middle grounds. A miniature train that thrilled children and adults alike was available, as well as exciting bumper cars and even a bantam tractor to motor along the park.

Water attractions were provided with canoe rentals and the famous "Shoot the Chutes." This highly promoted park ride was a short-lived attraction as one individual lost their life in an accident. The ride consisted of a boat, which was manually cranked up a large a wooden tower then released with the boat sliding down and splashing into the reservoir. Fireworks were usually displayed every Fourth of July until yet another accident claimed the life of a bystander.

The current pool, shelter houses, and band shell were all built during the years of the Depression, mainly 1934–35. The bricks to build these structures were recycled from the former pumping station, which stood at the west edge of the old reservoir. Green Mill gardens, a popular hangout, was built during the war years and provided roller skating and romantic dances from the likes of Glenn Miller and Tommy Dorsey.

The automobile and changes in lifestyles slowly choked the life out of Riverside in the 1970s. However, the pool was rebuilt and services modernized and other positive changes have taken place. Sadly, the old concession stands and the taffy building, along with the Green Mill, have long since been razed. Close your eyes, grab for the brass ring, and take another bite out of that freshly made cinnamon taffy to truly enjoy these postcards!

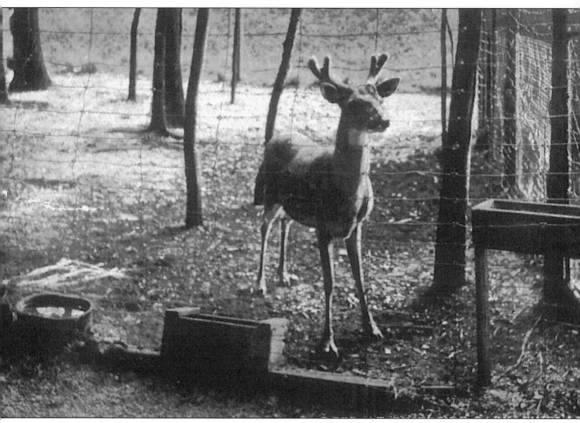

THE PETTING ZOO. A petting zoo was located at Riverside Park. Deer, raccoons, rabbits, and other such animals were available to see, feed, and touch! 1907 vintage.

A Daring Boater Close to the Dam Off of East Main Cross Street. 1909 vintage.

Same Dam But Different View of the Area Surrounding the Park. 1909 vintage.

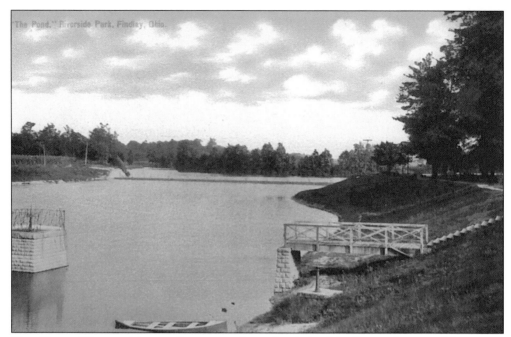

THE POND. The pond is actually a reservoir used to help fight fires and pumped into some homes (it was unfiltered). 1914 vintage.

FOREST SERIES. This is a series of postcards showing the primeval beauty of the forest-like setting. 1906 vintage.

THE FORESTED PARK WITH ADVERTISING CLUTTERING THE TREES. 1908 vintage.

SCENIC POSTCARD SHOWING A QUIET PASTURE WITH SHEEP GRAZING. 1911 vintage.

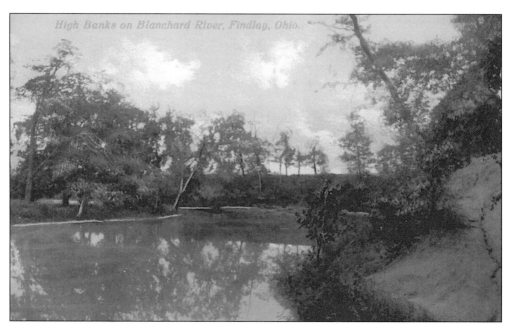

THE HIGH BANKS NEAR THE PARK. 1910 vintage.

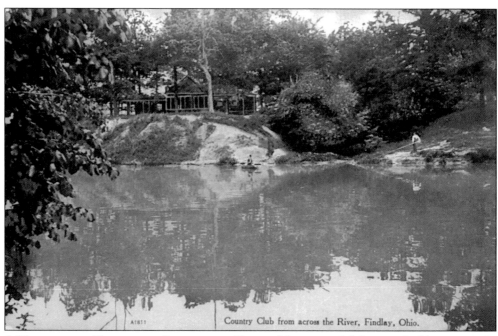

A VIEW OF THE CLUB FROM ACROSS THE RIVER. A boater and fisherman hold court out in front. 1909 vintage.

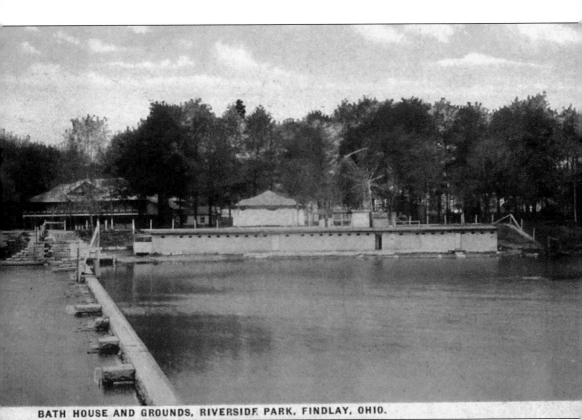

BATH HOUSE AND GROUNDS, RIVERSIDE PARK, FINDLAY, OHIO.

AN IMAGE LOOKING SOUTH FROM THE EDGE OF THE OLD RESERVOIR. The bathhouse occupies the bank while a Ferris wheel is seen in the background. Rides were added a few years after the opening of the park in 1904. A small roller coaster, gas miniature tractors, the Saber Jet, miniature trains, cars, and boats gave the young people something to scream about. A dodge car was housed in a building next to the garage for the train ride. 1912 vintage.

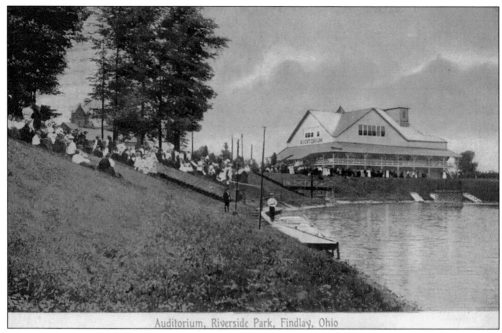

Auditorium, Riverside Park, Findlay, Ohio

THE AUDITORIUM. This is one of many different views of the large wood auditorium located at the west end of the old reservoir. 1910 vintage.

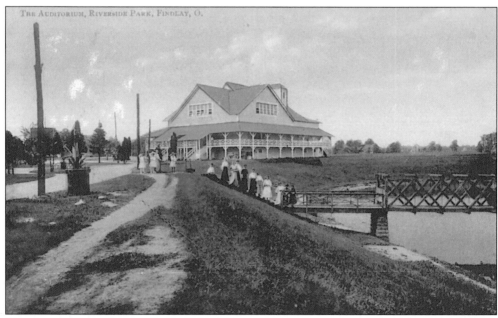

THE AUDITORIUM, RIVERSIDE PARK, FINDLAY, O.

THE AUDITORIUM BEING GRACED WITH LADIES STANDING ON THE STEPS NEAR A DOCK. The card was compliments of D.H. Thompson of the Findlay Fire Department. 1908 vintage.

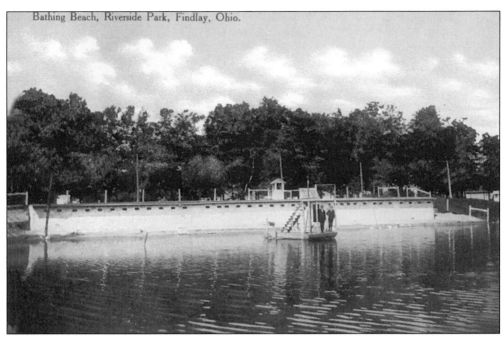

Bathing Beach, Riverside Park, Findlay, Ohio.

A CLOSER VIEW OF THE BATHHOUSE. Two men in regular Sunday suits stand on the diving platform. 1909 vintage.

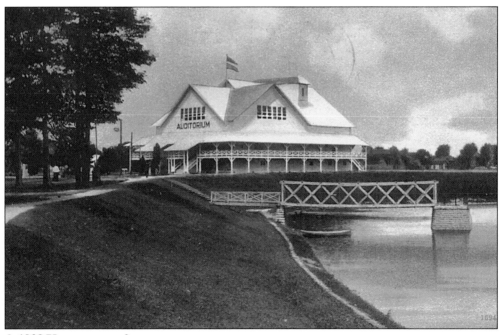

A 1908 VIEW OF THE AUDITORIUM.

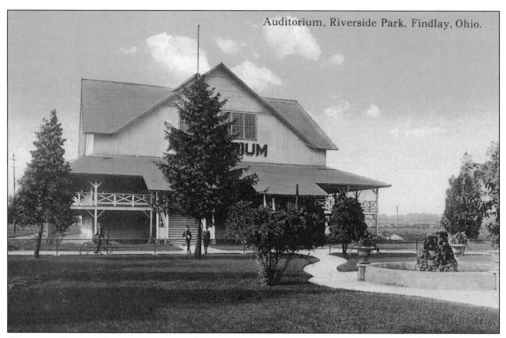

GROUND LEVEL IMAGE OF THE AUDITORIUM LOOKING NORTHEAST. Three boys pose patiently on the railing. 1909 vintage.

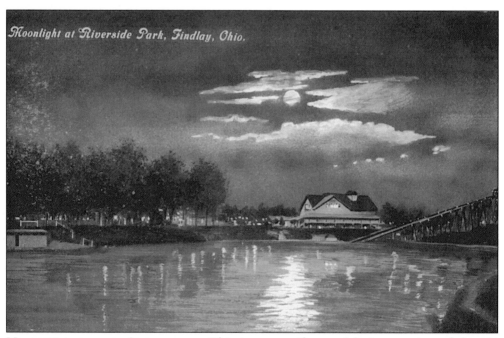

NIGHTTIME AT THE AUDITORIUM. This is a magnificent nighttime version of the old reservoir and auditorium, and the chute-the-chutes ride. 1910 vintage.

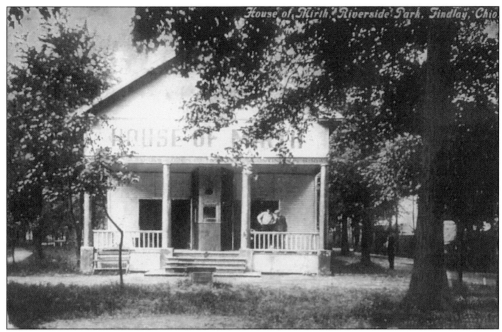

THE FRONT OF THE HOUSE OF MIRTH. This was a popular spot to see the latest in moving pictures that were accompanied by a pianist and organist. Tents are to the right. 1913 vintage.

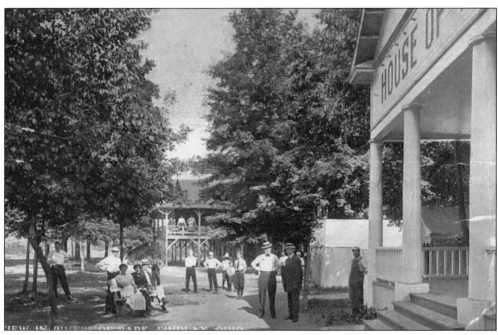

A BEAUTIFUL POSE BY HAPPY TOURISTS IN FRONT OF THE HOUSE OF MIRTH. The 30-foot by 70-foot building was moved from Mortimer in 1908 by two men from Fostoria. They went bankrupt in 1909 and sold the assets to the Haley family, who operated the steamer, *Pastime*. 1914 vintage.

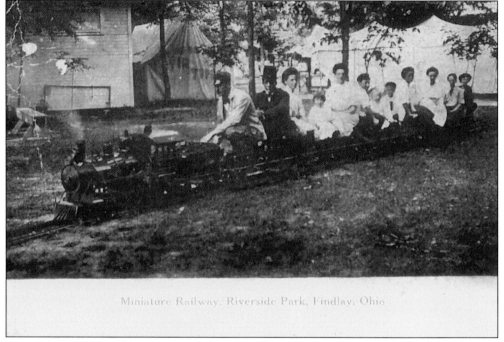

Miniature Railway, Riverside Park, Findlay, Ohio

THE FIRST OF TWO MINIATURE RAILROADS WHICH OPERATED FROM 1908 TO ABOUT 1977. This one was steam powered. 1909 vintage.

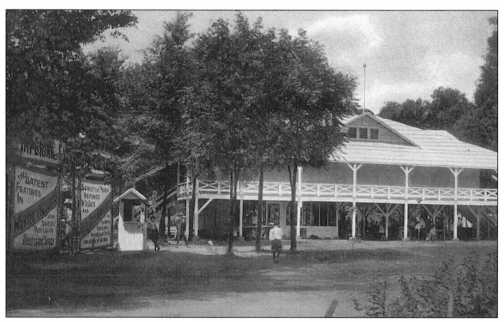

THE DANCE HALL AND PAVILION THAT WAS EAST OF THE MIRTH HOUSE. It too showed moving pictures, with banners advertising the latest features. 1910 vintage.

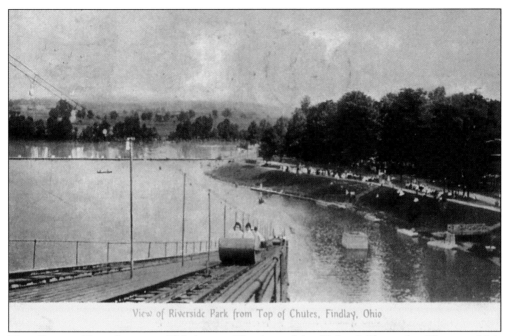

View of Riverside Park from Top of Chutes, Findlay, Ohio

THE CHUTE-THE-CHUTES. This is a terrific view of the ill-fated Chute-the-Chutes, which operated for only a few years in the west end of the reservoir. 1910 vintage.

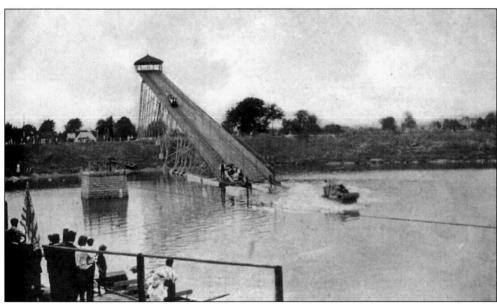

"THE LONGEST IN THE WORLD." The thrilling plunge into the cold waters was a treat in the hot summer months. The ride was shut down around 1908 after a North Baltimore boy lost his life. 1910 vintage.

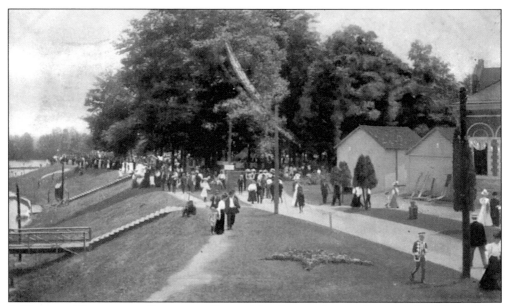

A HOLIDAY VIEW OF THE SWIMMING POND. The decorated pump house and uniformed boy give credence to this speculation. 1908 vintage.

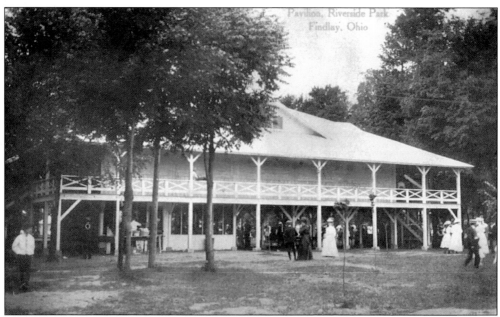

A 1908 VIEW OF THE DANCE HALL AND PAVILION. Children in their Sunday best play out front.

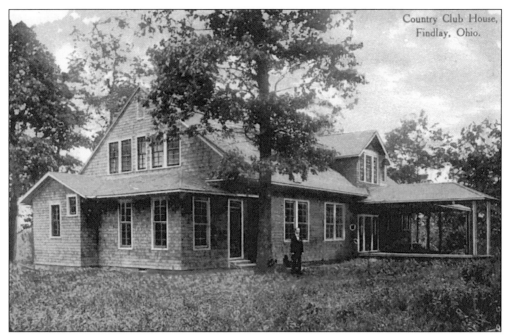

THE FINDLAY COUNTRY CLUB. Down the river from the park was the Findlay Country Club. Pictured here is the club's modest main house. 1912 vintage.

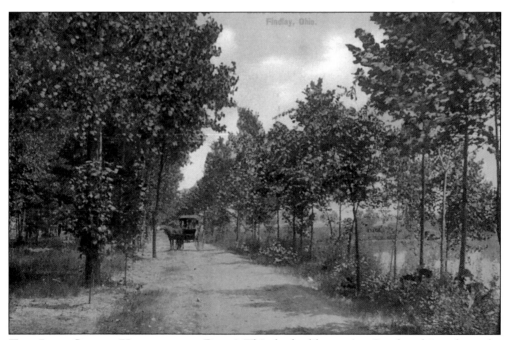

Findlay, Ohio.

THE LAST SCENIC VIEW OF THE PARK! This looks like a nice Sunday drive along the Blanchard River in 1908.

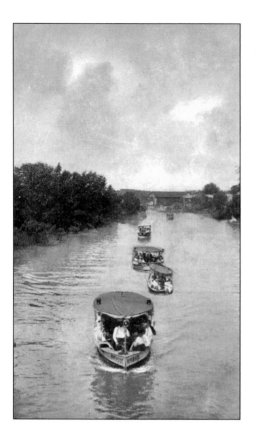

THE APTLY NAMED "MOSQUITO FLEET" ON THEIR WAY TO RIVERSIDE. This is one of many operators who transported passengers from downtown to the park. 1907 vintage.

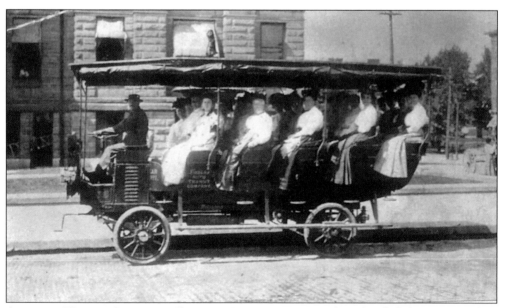

ANOTHER WAY TO GO TO THE PARK, BY MOTOR COACH! These lovely ladies pose on their way to have some fun. 1911 vintage.

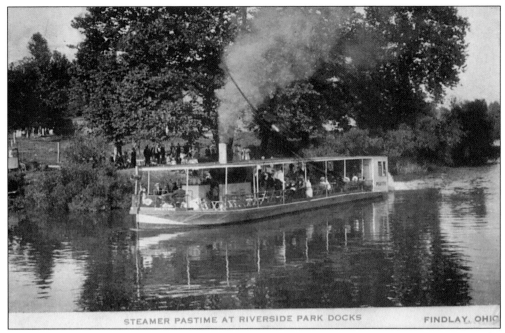

STEAMER PASTIME AT RIVERSIDE PARK DOCKS FINDLAY, OHIO

THE *PASTIME* EN ROUTE TO DOWNTOWN. It boasted an organ to entertain passengers and a collapsible smokestack to safely go under the four bridges it encountered.

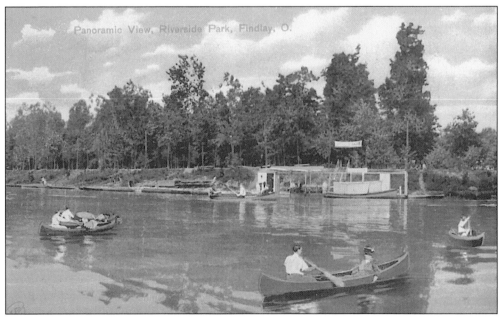

Panoramic View, Riverside Park, Findlay, O.

AHH... A DAY ON THE RIVER WITH YOUR BEAU IN A RENTED CANOE! 1907 vintage.

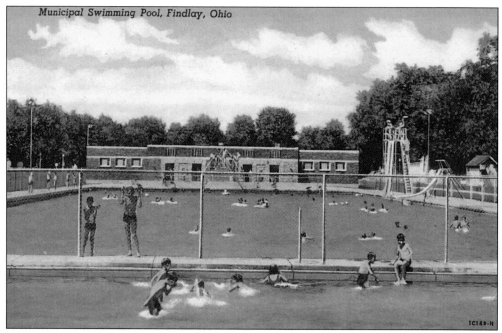

THE POOL AT THE PARK. The pool was not available until the 1930s, when it was dug mostly by hand by the W.P.A. during the Depression. 1950 vintage.

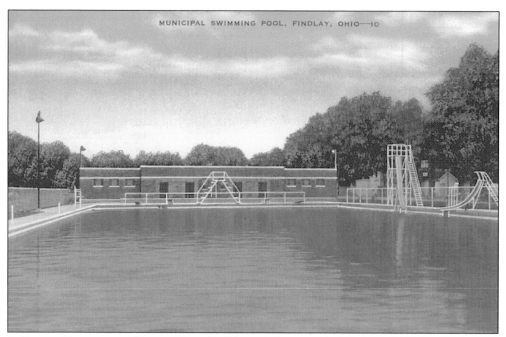

A SILENT DAY AT THE POOL. The tall slide and the curved slide tore many bottoms out of bathing suits.

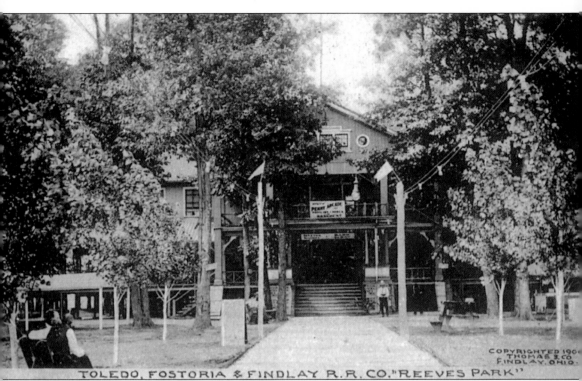

TOLEDO, FOSTORIA & FINDLAY R.R. CO."REEVES PARK"

REEVES PARK. Reeves Park was located in Arcadia, where it began before Riverside Park. Excursions by local railroads provided plenty of tourists. It contained many amenities, including bowling, a ball field, arcade, dance hall, and a Ferris wheel, which eventually was removed to Riverside after the park began to falter. The wooded area west of Dicken Foundry on State Route 12 still exists, but only in memory, as all buildings are long gone.

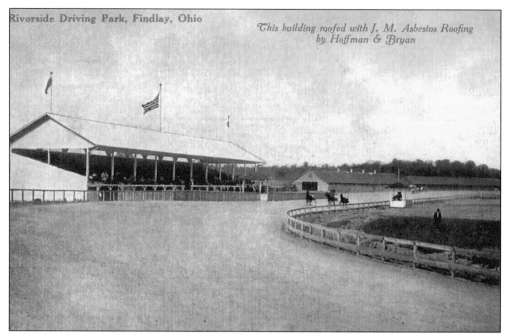

A HOFFMAN AND BRYAN ADVERTISEMENT. This is an advertising card from Hoffman and Bryan, who roofed the large grandstand at the Riverside driving park. The park was located between Country Club Drive and Tiffin Avenue. 1922 vintage.

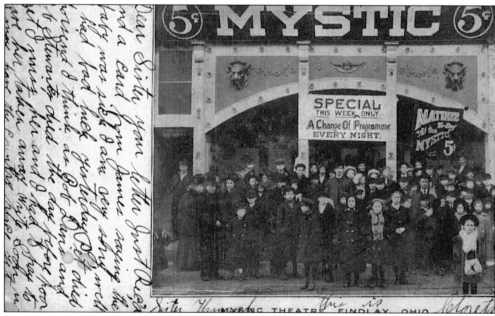

THE MYSTIC THEATER. The theater was located at 510 South Main, in the Latham Courtyard. Many remember it as The Royal. It opened in 1907, and for 5¢ you could watch the 22-minute movie, *Fairyland*. It was razed in 1970.

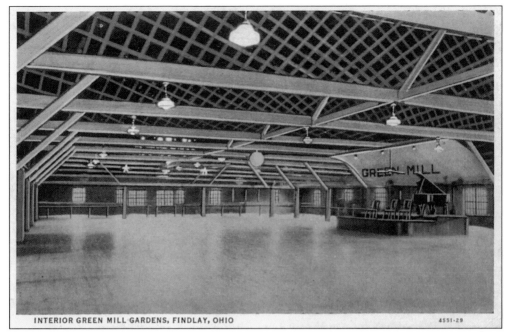

INTERIOR GREEN MILL GARDENS, FINDLAY, OHIO 4551-29

INTERIOR OF THE GREEN MILL DANCE HALL AND LATER ROLLER SKATING RINK. Built on the site of the old icehouse, it opened in 1925 and saw the likes of both the Glenn Miller and Tommy Dorsey bands, as well as Alice Cooper in 1970. It was razed in 1978.

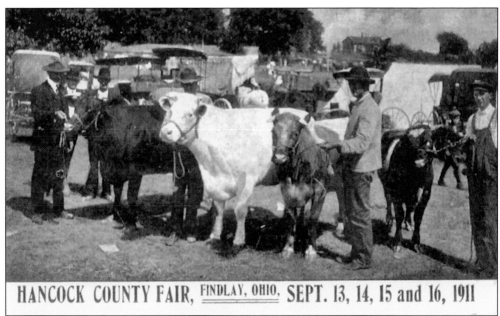

HANCOCK COUNTY FAIR, FINDLAY, OHIO, SEPT. 13, 14, 15 and 16, 1911

FARMERS SHOWING OFF THEIR PRIZED CATTLE AT THE HANCOCK COUNTY FAIR. At the time of this postcard, the fair was located south of Findlay on Sixth Street west of South Main Street. It did not move to its present location until the 1930s.

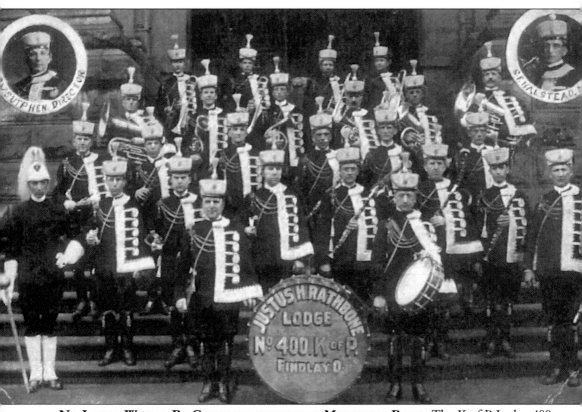

No Lodge Would Be Complete without a Marching Band. The K of P Lodge 400 poses in front of the Courthouse. 1907 vintage.

The Famous Old No. 400 K. of P. Band, of Findlay, Ohio, under the directi
G. V. Sutphen, with almost a complete set of instruments made by the
C. G. Conn Co., of Elkhart, Ind.

THE FAMOUS OLD. This is the same lodge, but referred to as The Famous Old. Conn Instruments was instrumental in this advertising card that probably made its way to numerous other lodges. 1909 vintage.

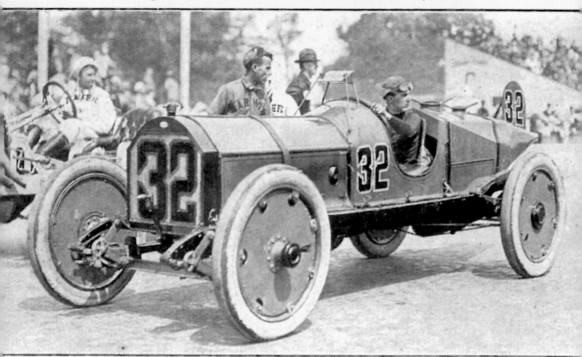

RAY HARROUN, Findlay's Noted Driver, in his Marmon "Wasp"

THE BRICKYARD IN INDIANAPOLIS. In 1911 at the Brickyard, Ray Harroun, one-time resident, cruised to victory at an average speed of nearly 70 mph. The Mystic Theater provided this promotional card. Note the rear view mirror located on the top dash. Ray invented this and other improvements to the automobile.

Five

THE BACKBONE OF THE COMMUNITY, BUSINESS AND INDUSTRY

*F*indlay *was established as a fort and as an outpost during the War of 1812. After the war ended settlers stayed on and made claims on the land and began trading with other towns located nearby and accessible by the Blanchard river. Typical early merchants who dealt in stock from St. Louis, New York, Chicago, and other larger cities set up business along side the blacksmith, coopers, carpenters, and other skilled laborers who produced goods locally. It wasn't until the Gas and Oil Boom that so explosively put Findlay on the map as an upcoming city, that long term factories and other shops were built. Prospective companies relocated for the free gas and other peripheral businesses followed.*

Early businesses like Marathon Oil, Cooper Tire, and the numerous glass companies brought thousands of new citizens to Findlay. Thus began the era of growth and prosperity. By the time postcards became popular, the glass companies had folded up or moved out when the gas was spent. By then, however, the population base was large enough that other companies still set up shop to the thousands who stayed long after the oil fields opened up out west.

Many images will look familiar, while others will be a test of your imagination and knowledge! Many buildings and factories that were originally built for a specific business evolved into new endeavors. These businesses used postcards for advertisements and enticements to poised clients and employees. Let's see how many you remember!

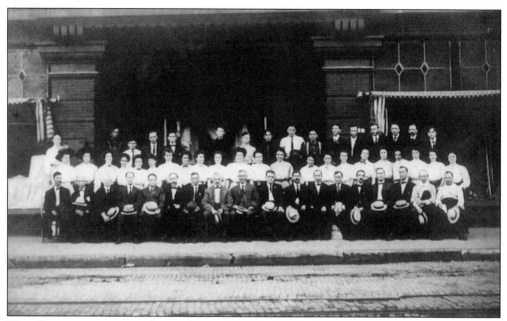

THE EMPLOYEES OF THE GLASS BLOCK, 500 SOUTH MAIN STREET. It appears that the 25 females were wearing uniforms consisting of a white blouse, black skirt, and black tie. The 31 males wore suits and skimmers (straw dress hats). The two older men in the middle may be the owners or the managers. 1908 vintage.

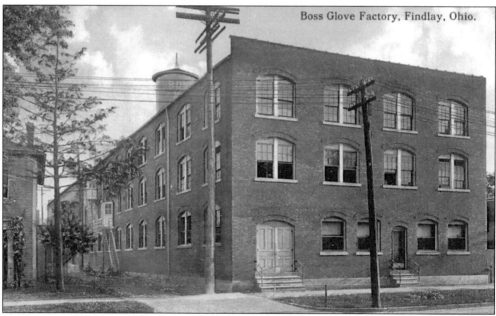

THE BOSS GLOVE FACTORY ON WEST MAIN CROSS STREET. It opened in 1903 by the Houck family, but was bought out less than a year later. It had plants in Pandora and Bluffton. 1911 vintage.

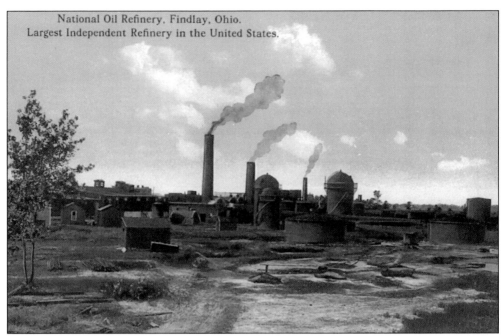

National Oil Refinery, Findlay, Ohio.
Largest Independent Refinery in the United States.

ONE OF OHIO'S FIRST AND LARGEST REFINERIES. It was established in 1886. The National Refinery and the Peerless combined in the late 1890's and became one large plant. 1909 vintage.

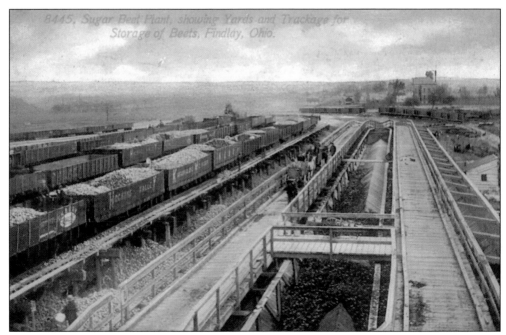

8445, Sugar Beet Plant, showing Yards and Trackage for Storage of Beets, Findlay, Ohio.

SUGAR BEET PLANT. Sugar beets were a staple crop grown in the early 1900's until the late 1980s. The plant was located in the West Park area west of Lima Avenue. Remember the smell in the fall during processing?!

Offices and Laboratory of The Glessner Medicine Co., Findlay, Ohio.

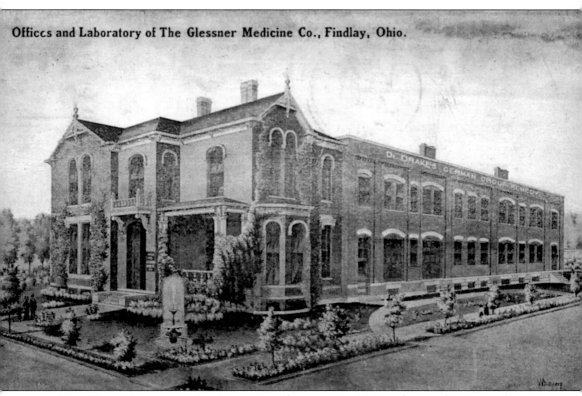

THE TUPO VAPORIZER. Starting out in a basement in 1900 and expanding into a home on East Sandusky in 1910, the Glessner family boasted of sales in the hundreds of thousands fueled by the famous Tupo Vaporizers. They sold $350,000 in Chicago alone in 1930!

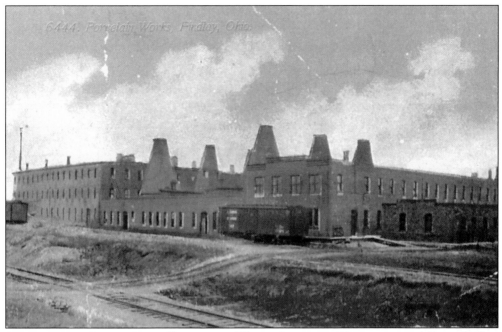

IMAGE OF THE LARGE BRICK PORCELAIN WORKS LOCATED NORTH OF THE CITY, 1913.

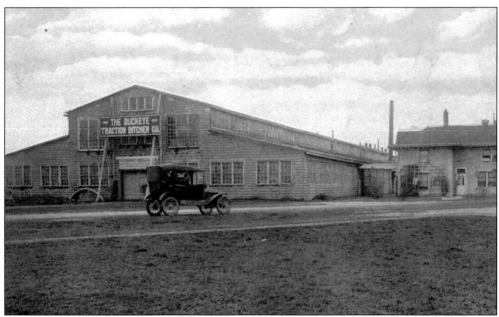

THE BUCKEYE TRACTION DITCHER. This plant was located off Crystal Avenue. In 1901 it began producing equipment to drain the Great Black Swamp, and later became Garwood Industries.

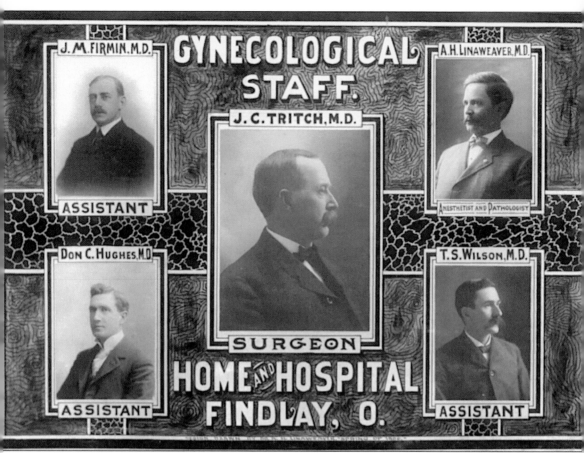

DOCTORS OPENED CLINICS AND SMALL HOSPITALS. Like today's doctors they combined talents and used postcards to promote their business. 1915 vintage.

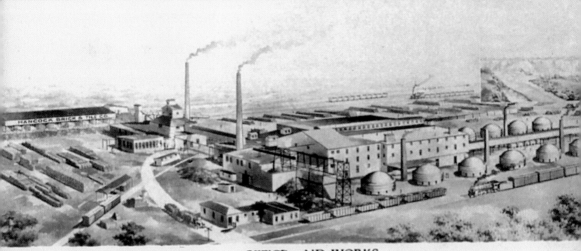

OFFICE AND WORKS

THE HANCOCK BRICK & TILE CO.
FINDLAY, OHIO

THE HANCOCK BRICK TILE. This plant was started in 1887 by Daniel Child, George Dorney, and John Murry. The presence of clay under much of Findlay gave rise to the manufacturing of drainage tile. Child bought out the other partners and became the sole owner. It changed its name to Hancor and began using plastics for tile production. The large and hot round furnaces were used up until the 1960s.

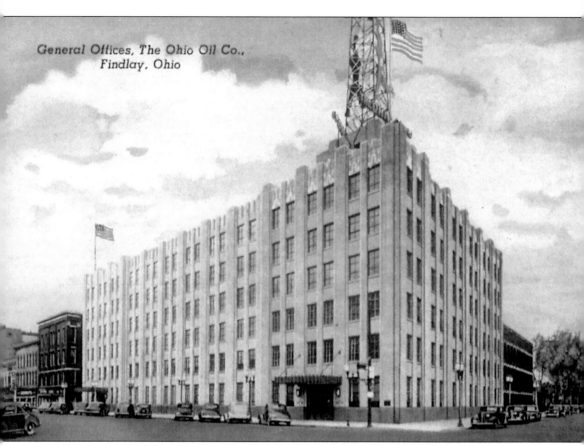

General Offices, The Ohio Oil Co.,
Findlay, Ohio

THE FAMOUS OHIO OIL COMPANY HEADQUARTERS. Here, the large illuminated sign with the Greek runner states, "Best in the Long Run." In 1886 the Donnell family started the company after the Standard Oil Company was split up. The building remains a landmark in downtown Findlay.

Six

RELIGIOUS ENDEAVORS

*O*ne of the basic tenets of our government is freedom of religion. Thus begins the saga of variations and varieties of religions and their places of worship. Some churches started out as small-framed, simple structures while others began as Gothic vestiges for all to marvel at. Whatever religion you practice, it is interesting to visit these places of worship. The craftsmanship is stupendous and the aura that circulates while one is inside is gratifying.

 Like many towns and cities in the Midwest, Findlay also had revivals. Some took place in tents during the summer months while others built structures to last for years. Perhaps there is another Great Awakening lurking around the corner.

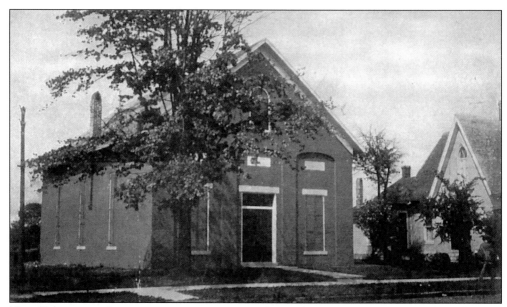

THE REFORMED CHURCH WAS LOCATED ON EAST STREET. It was originally part of the German Lutherans in the 1850s; however a split in the congregation resulted in two churches forming with the Reformed, building this church in 1860. It was demolished in the 1980s when the parkway was built.

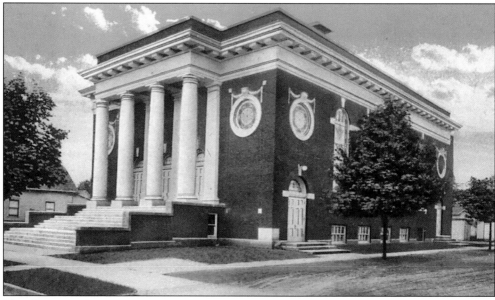

THE SECOND FIRST CHURCH OF CHRIST CHURCH BUILT ON THE CORNER OF FILMORE AND NORTH MAIN STREETS. The first was built in 1901 and burned in 1913. This postcard is from 1915.

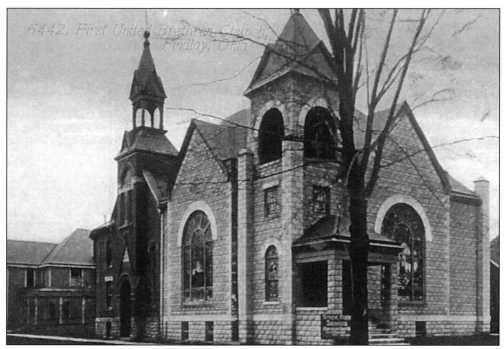

THE FIRST UNITED BRETHREN CHURCH. The congregation of the First United Brethren was organized in 1853 and this was their second church structure, which still stands on West Sandusky and Southwest Streets.

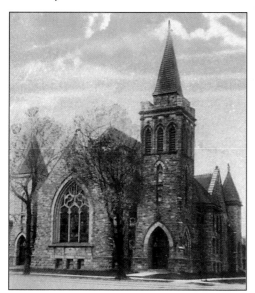

THE FIRST PRESBYTERIAN CHURCH. This structure stood on the corners of West Lincoln and South Main Streets, replacing the earlier one on the corner of Hardin and South Main Streets. It was dedicated in 1901 and burned in 1952.

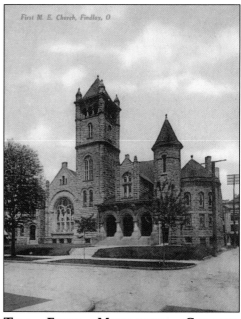

THE FIRST METHODIST CHURCH, FOUND ON THE MOST POSTCARDS. This church is also the second, erected in 1901. 1908 vintage.

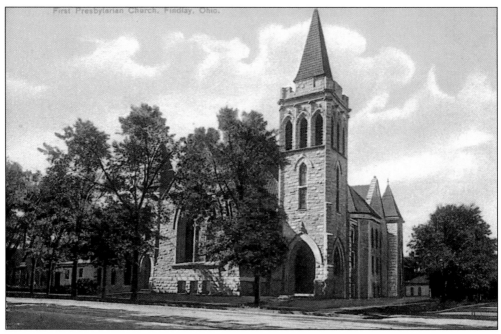

First Presbyterian Church, Findlay, Ohio.

ANOTHER VIEW OF THE PRESBYTERIAN CHURCH. 1915 vintage.

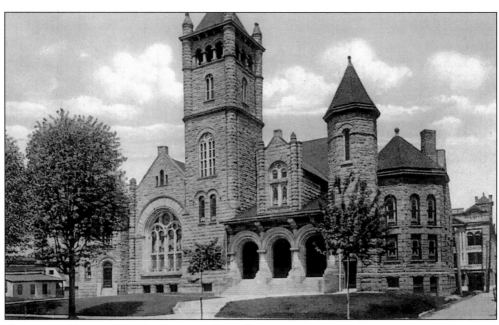

THE FIRST METHODIST CHURCH ON EAST SANDUSKY ST. 1909 vintage.

THE EARLIEST POSTCARD OF ST. MICHAEL'S CATHOLIC CHURCH. A fire burned the first one down, originally located on the corner of West Hardin and Cory Streets. The cornerstone was laid in 1866 and completed in 1867. The only Catholic Church in Hancock County, it boasts a congregation of over 3,000. 1908 vintage.

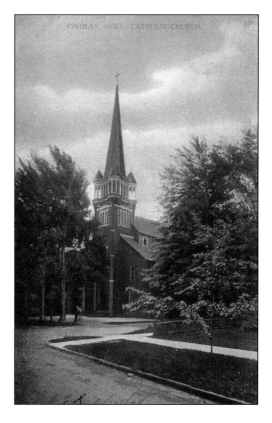

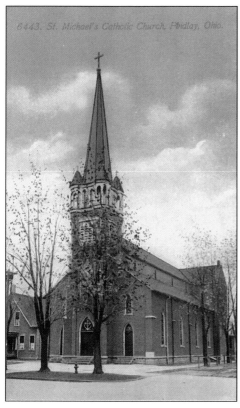

ST. MICHAEL WITH THE RECTORY ATTACHED TO THE EAST SIDE. This was later converted to a convent for the Sisters of Charity. The original bell, cast in Cincinnati in 1865, is still in use.

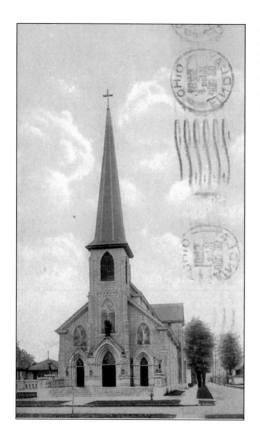

THE FIRST OF TWO OF THE NEWLY REMOLDED EXTERIOR. Father Ogle decided to make the church more Gothic and added the "premastone" and new glass from Germany. The church is presently going through a $500,000 restoration.

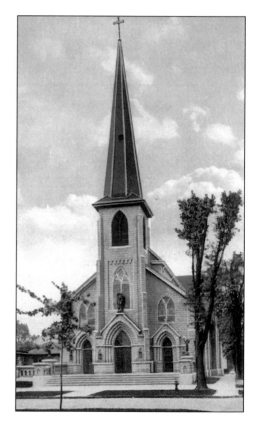

THE MISSING RECTORY, WHICH USED TO STAND NEXT TO THE CHURCH. This structure was razed in 1999, and is now a parking lot with a new, larger one in a converted home next to the lot. This is the second oldest Catholic Church in the Toledo Diocese and the oldest standing church in Hancock County.

Seven

THE GOVERNMENT

Wthout the existence of some form of government, no nation, state, or city could survive. Chaos would reign supreme and the survival of the fittest would be the norm. In order to promote the positive aspects of government, many cities built lavish buildings when possible, while others squandered less money and built simple utilitarian edifices. Regardless of the style, each tell a story of the culture and the economics of that particular generation. The fire departments were simple buildings early on. Findlay did not really have a full-blown police department until after the gas and oil booms. The post office was small and was sometimes housed inside a leased property. The public library began modestly in the basement of the Courthouse. The 1902 municipal building was designed to compliment the courthouse while the county jail of the 1870s resembled a fine middle class home.

Today the needs of the populous have changed and so has the government: it keeps getting bigger! We have witnessed the loss of many of these above-mentioned properties. They have been "replaced" with new and modern buildings. It will be interesting to see what survives in the next 100 years.

We have witnessed the grandeur of the courthouse; now let's look at other buildings that were used for the people and by the people.

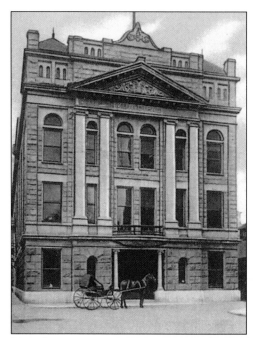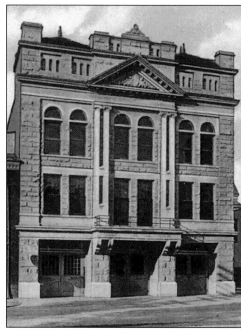

THE OLD MUNICIPAL BUILDING. This building occupied the west side of the Courthouse Square. It was built in 1901 and complimented the courthouse. The Central Fire Department was housed to the south side on Crawford Street. It was razed in the 1980s to make room for the new municipal building. 1904 vintage.

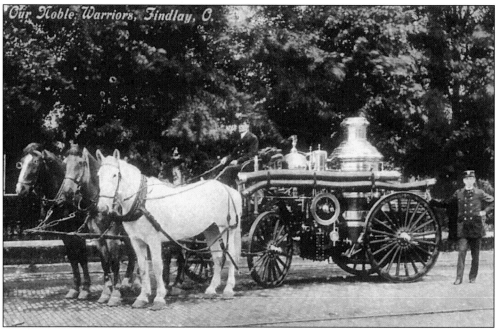

"OUR NOBLE WARRIORS" BOASTS THE FRONT OF THIS CARD. The first fire department was a volunteer one until it became apparent that the rapid growth during the oil and gas boom warranted a full-time department. 1908 vintage.

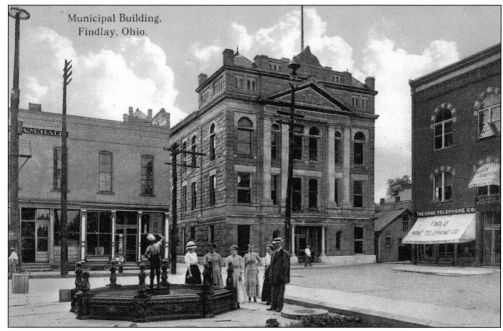

A DIFFERENT VIEW OF THE MUNICIPAL BUILDING. This one shows the "Leaky Boot" fountain at the rear of the Courthouse. 1910 vintage.

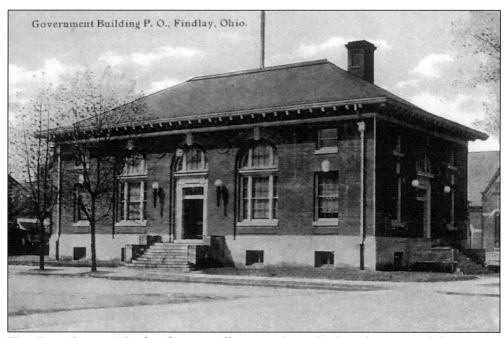

THE POST OFFICE. The first few post offices were located in leased spaces until this one was built in 1906. It later became the public library in 1932 after a new post office was built. This building was razed in 1990. 1915 vintage.

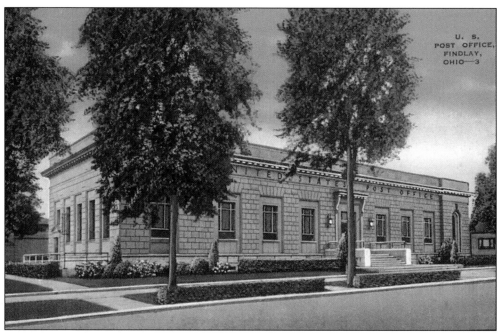

THIS BEAUTIFUL POST OFFICE STILL STANDS. It was built around 1931–32. 1935 vintage.

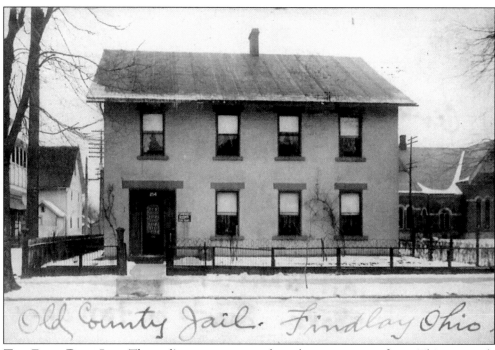

THE FIRST REAL JAIL. The earlier ones were crude and easy to escape from. This postcards reads, " . . . Findlay is the most interesting places I have seen . . . Irene's and Kates birthplace . . . used as a jail." 1912 vintage.

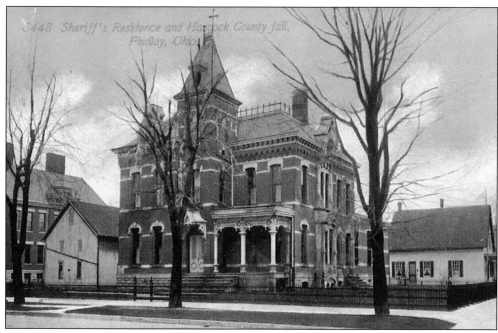

BEAUTIFUL JAIL AND SHERIFF RESIDENCE BUILT IN 1879. It housed male prisoners in the back, with females being locked into back bedrooms. The structure had 3-foot thick walls. Sadly, it too was torn down in 1990.

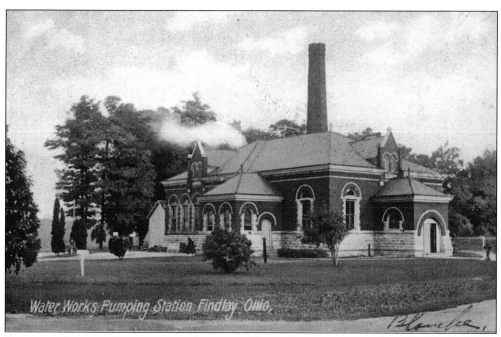

PUMPING STATION LOCATED AT RIVERSIDE PARK. It was constructed in 1889 and pumped unfiltered water to many homes. It was also used by the fire department. 1907 vintage.

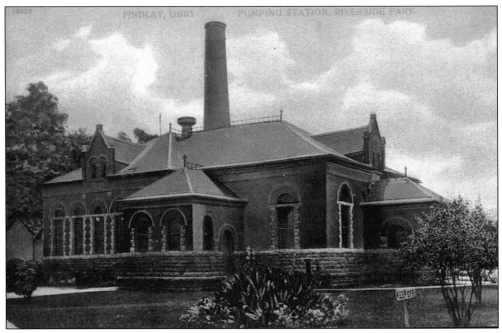

DIFFERENT VIEW OF PUMPING STATION AND WATERWORKS. It was torn down in 1930 and replaced by the one on Blanchard Street. The bricks were recycled into the shelter houses and other structures that have been torn down. 1909 vintage.

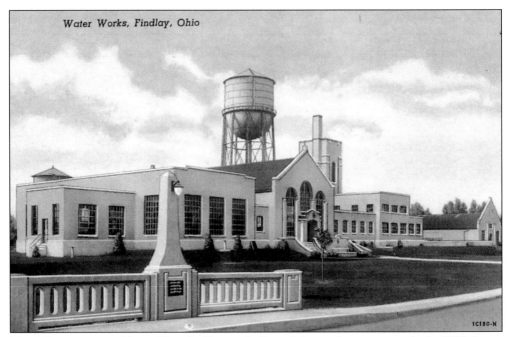

THE WATERWORKS. Mayor Lincoln Groves dedicated the modern waterworks in 1930. It was built in a Spanish Mission Style that was popular then. 1931 vintage.

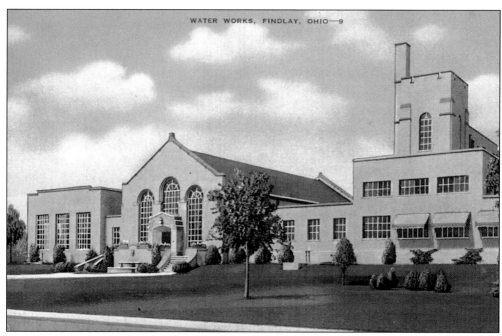

THE WATERWORKS. The Waterworks was used to filter and purify the water that was now being pumped into the homes. Fluoridated water was added in 1957.

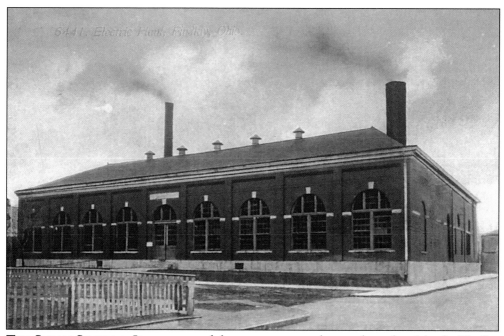

THE STEAM STATION. Steam powered dynamos were used to produce electricity for Findlay in the late 1800s. The displaced steam was pumped into large tiles which provided "free heat" or city heat for many homes. A remnant exists of this station on Liberty and Putnam Street. 1908 vintage.

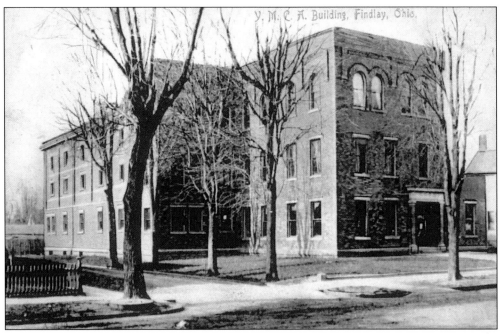

THE FIRST YMCA BUILDING ON THE SOUTH SIDE OF EAST SANDUSKY AT 129. It caught fire in the 1950s and was replaced by the current one in 1963.

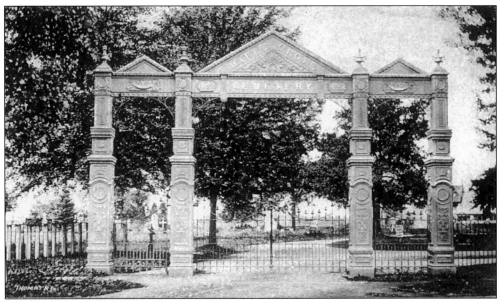

MAPLE GROVE CEMETERY. This is the imposing cast iron entrance, which was originally on River Road, which ran along the swale at Rawson Park. This cemetery was built with the Catholic cemetery in the 1860s. Many early settlers were re-interred here after earlier cemeteries were moved to accommodate town expansion. 1909 vintage.

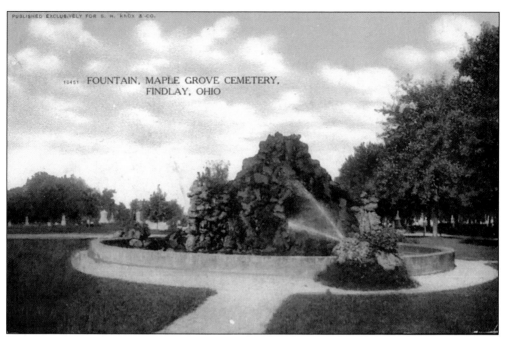

10451 FOUNTAIN, MAPLE GROVE CEMETERY,
FINDLAY, OHIO

THE ROCK FOUNTAIN THAT GRACED THE CEMETERY. 1909 vintage.

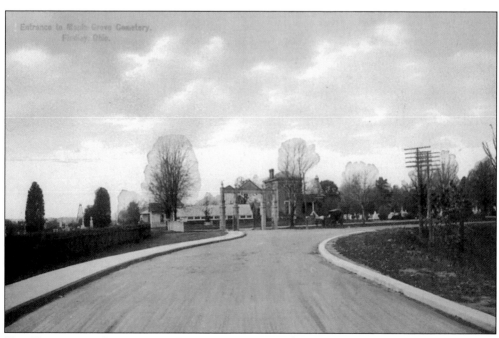

Entrance to Maple Grove Cemetery.
Findlay, Ohio.

THE ROAD THAT LED TO THE EARLY ENTRANCE. The superintendent's home is visible.

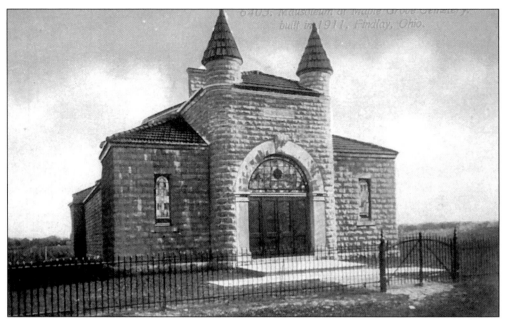

ONE OF TWO LARGE MAUSOLEUMS BUILT IN 1911. Both mausoleums were built by a factory for its deceased workers and their family members. Once beautiful, it declined due to lack of maintenance and was eventually torn down in the 1980s.

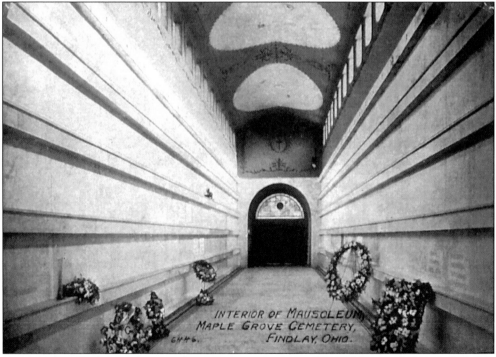

EXTERIOR OF SPANISH MISSION REVIVAL MAUSOLEUMS. Beautiful stained glass and marble graced these buildings. The bodies of those who had no living relatives were removed and reburied at the north end of Maple Grove.

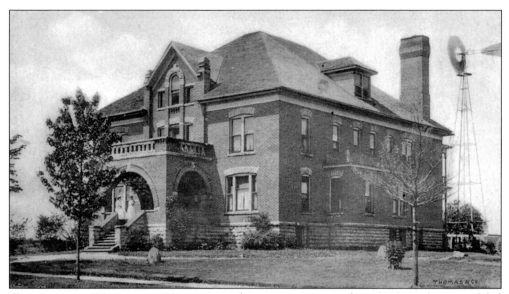

THE FINDLAY HOME AND HOSPITAL. This structure opened in 1898 in the remodeled French home on South Main Street. 1907 vintage.

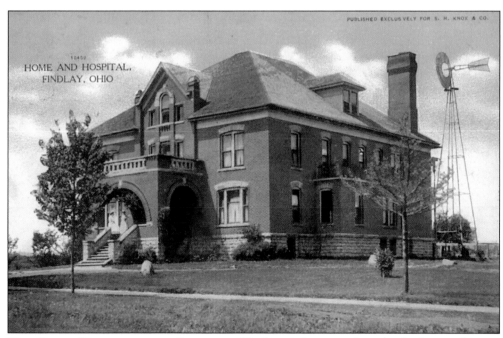

THE COLOR VERSION OF THE PREVIOUS. The hospital was a private institution until it was purchased by the county in the 1950s.

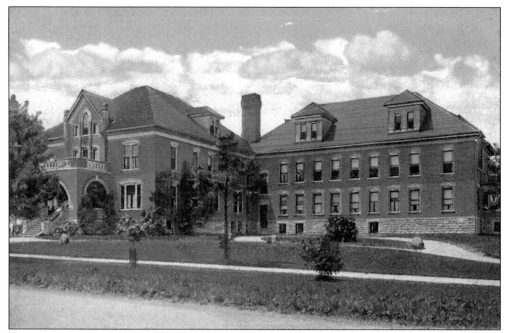

THE BLANCHARD VALLEY HOSPITAL. In the early 1950s the Findlay Home and Hospital became the Blanchard Valley Hospital. It leased the property from the county.

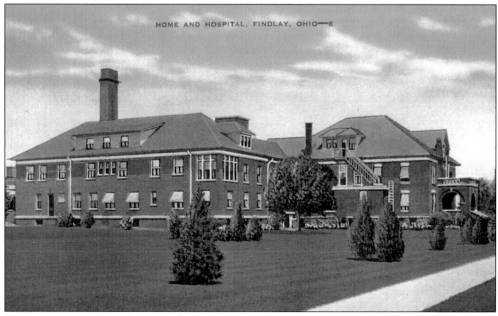

A NORTH VIEW SHOWING THE ADDITION.

Eight

THE IMPACT OF OIL

Oil, that dark specter of ancient life that died millions of years ago, provided Findlay and other towns with the catalyst for expansion, as well as creating some fortunes overnight! Without oil, Findlay may have only grown to a few thousand inhabitants with much less industry. Before the oil took hold, it was that clear, sulfurous, explosive vapor called gas that was drilled from below the Trenton limestone that took Findlay by storm. Natural gas was here for thousands of years. Early settlers digging wells for water sometimes hit a pocket or vein of gas and oil. It was thought to have been a nuisance. Yet some settlers discovered the power for heat and light that gas could provide. Some resourceful citizens used crudely designed systems to pipe the gas into cook stoves and fireplaces. It wasn't until 1884 when German physician Dr. Charles Oesterlin drilled the first successful commercial gas well that the use of gas became a serious business undertaking. The Great Karg well and the booming of Findlay is a well-known history lesson. The other businesses and craftsmen that followed stabilized and set in concrete the strong economy we all enjoy today.

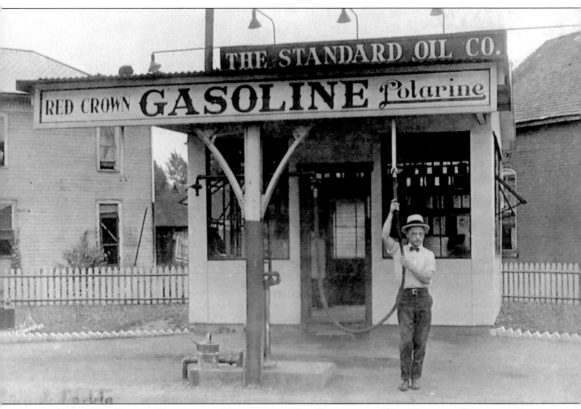

Mr. J.B. Shank Stands in Front of His Standard Oil Filling Station. It was located on the corners of North Main and Larkins. His dress by today's standards would make him a manager, not a pumper! White shirt, bow tie, and a hat isn't exactly what gas station attendants wear, but then again, it's all self-serve today. The card is dated June 28, 1919.

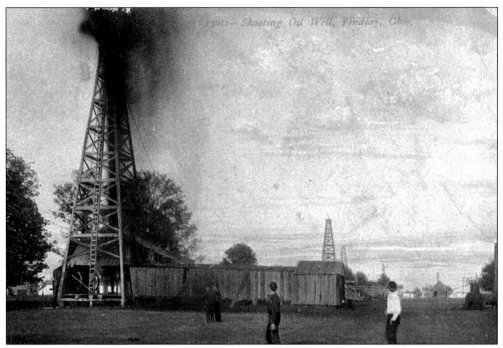

GUSHER! Nitroglycerine was used to bring an oil well in. Gushers like these were common in Findlay in the late 1890s and early 1900s. 1908 vintage.

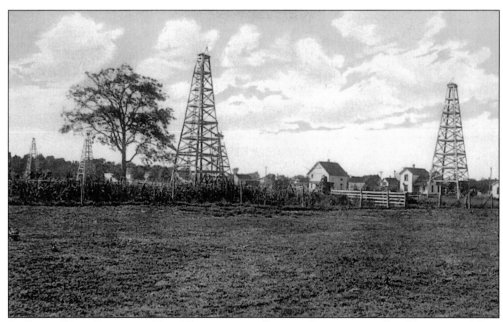

A GOOD VIEW SHOWING THE HARMONY OF FARMS, CROPS, AND OIL DERRICKS. Many farmers leased land and received a percentage of profits. There are still old abandoned wells scattered over the county. 1909 vintage.

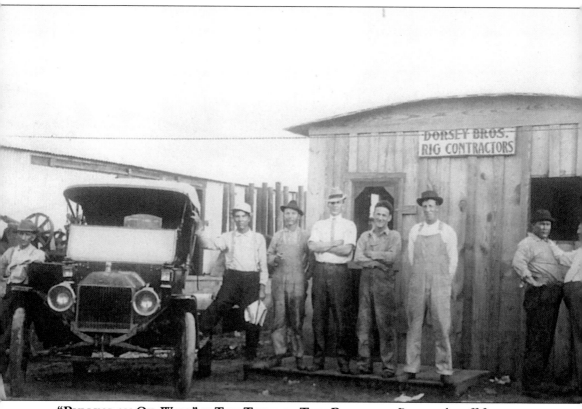

"PULLING AN OIL WELL" IS THE TITLE OF THIS POSTCARD. Power take off from tractors and small one-cylinder engines helped to pull out tools and such. 1907 vintage.

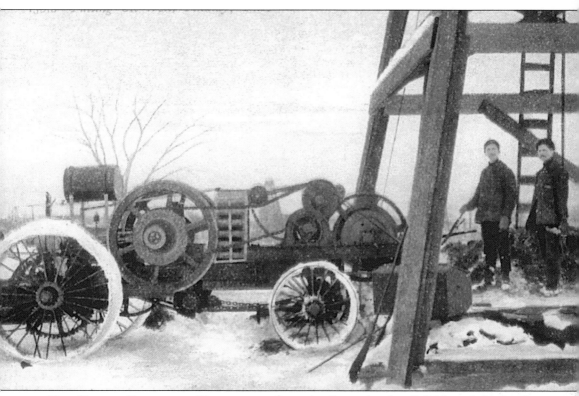

THE DORSEY BROTHERS. Riggers came from the Pennsylvania oil fields to help develop Findlay's oil. The Dorsey Brothers had this card made for advertising. The boss must be in the shirt and tie. 1909 vintage.

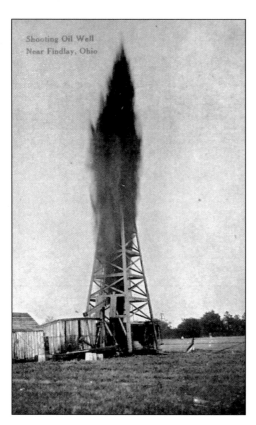

Shooting Oil Well
Near Findlay, Ohio

THERE SHE BLOWS! The shutter had to be open for a time in order to catch these gushers. Sometimes it would take hours to place a shut-off valve at the top of the well casing. 1908 vintage.

SMOKING WELL. Occasionally a well would catch fire and burn for days. The well-dressed men appear to be perfectly happy with their smoking well. 1909 vintage.

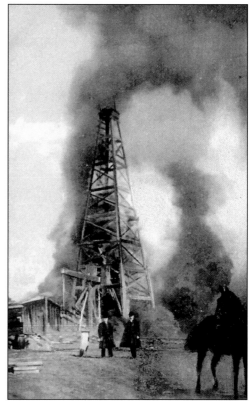

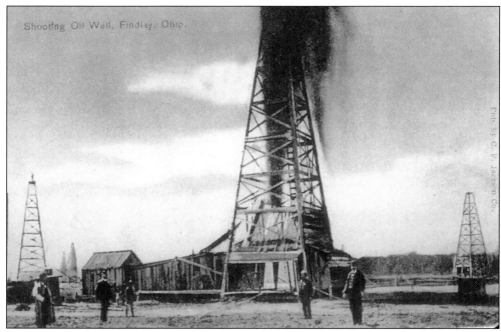

A Prosperous Looking Bunch! These folks are apparently the proud owners of this well. There is even a woman in the foreground. Most wells were strippers, producing only a few barrels a day.

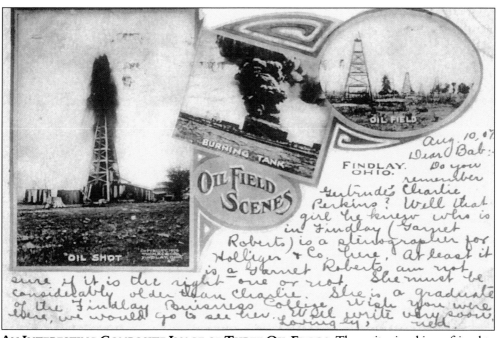

An Interesting Composite Image of Three Oil Fields. The writer is asking a friend to check on a woman that moved to Findlay. I wonder if they found her? 1906 vintage.

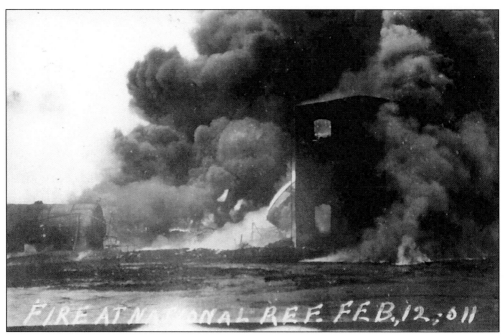

A DISASTER AT THE NATIONAL REFINERY WHEN A FIRE BROKE OUT, BURNING FOR DAYS. 1911 vintage.

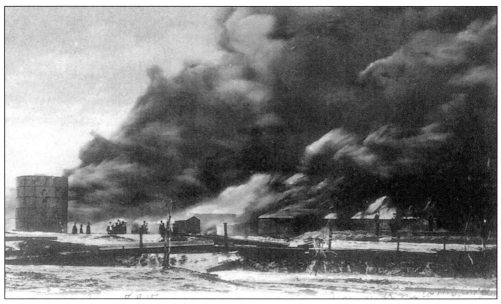

ANOTHER SMOKY MESS AFTER FIRE STRUCK THIS STORAGE TANK. 1907 image

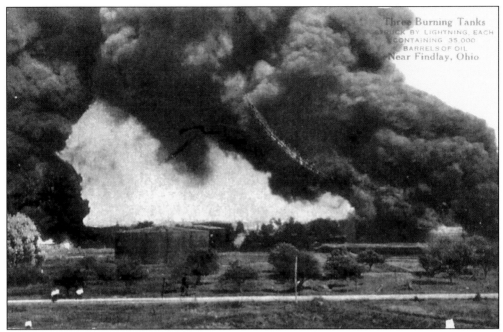

WHERE'S THE EPA WHEN YOU NEED THEM? Pictured are burning oil storage tanks. It appears that the entire refinery/storage facility is a complete loss. 1911 vintage.

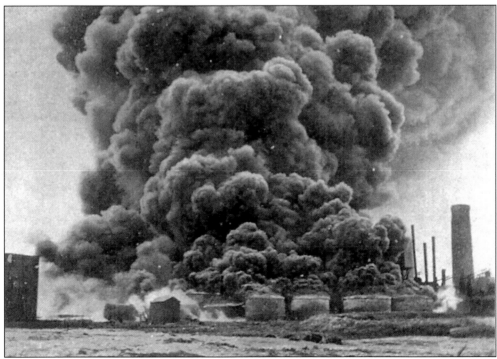

LIGHTING WAS THE CULPRIT IN THIS IMAGE. The tanks contain 35,000 barrels of oil. Fires like these just burned themselves out. The tops sometimes exploded and were blown a few hundred feet upwards!

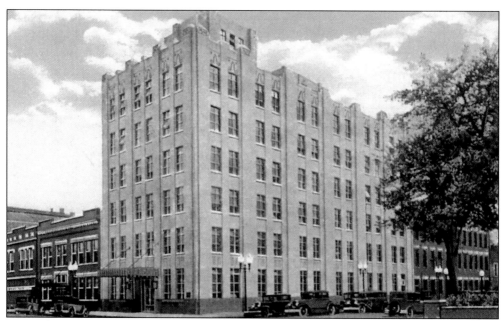

MANY WILL WONDER, WHERE ARE ALL OF THE MARATHON POST CARDS? Here is another view of the offices before any additions. 1934 vintage.

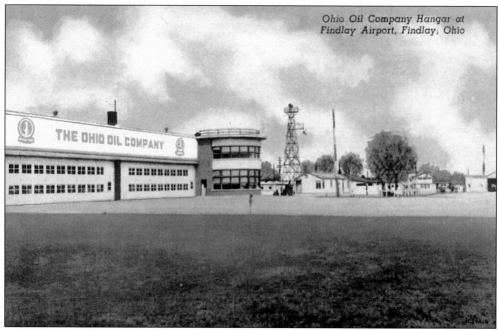

Ohio Oil Company Hangar at Findlay Airport, Findlay, Ohio

MARATHON AIRPORT. Marathon owned the airport out east, up until the city took over a few years ago. Mike Murphy, a barnstormer and all around great pilot, manned Marathon's airport for years.

Nine

TORRENTIAL RAIN, SOME ICE, AND A LITTLE SMOKE

Not all of the weather has been the best for Findlay and Hancock County. We have had our share of tornadoes, fires, ice storms, and our infamous floods. Many of these events were recorded by local photographers, placed on postcards, and sold locally at the dime stores. Some images are rare while others have been overused. It seems that the lowly Blanchard and the curves and dips through and around Findlay create the perfect arena for flooding. Of these floods, the 1913 Flood was the most photographed disaster. The horrific photos on postcards of the policeman who drowned were also commonly available.

The oil fields north of Findlay also provided for spectacular postcards. Oil storage tanks and the tank farms once dotted the area that is now I-75 and U.S. 25 for years. On occasion a decisive lighting hit would turn these steel structures into a raging, smoking cauldron that would burn for days. Relax—the tanks are long gone, but the murky Blanchard is still our liquid neighbor!

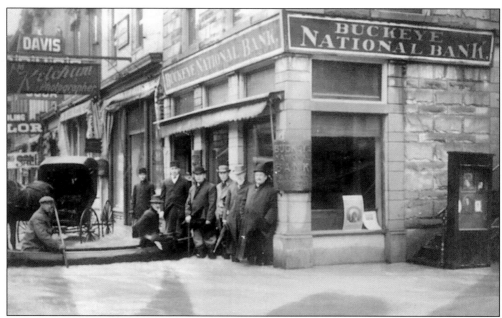

IN 1913 ON EASTER SUNDAY, MARCH 23, RAIN BEGAN TO FALL STEADILY IN FINDLAY. A terrible and dangerous windstorm had left the city in shambles just a few days ago on Good Friday. It rained 2.2 inches in less than an hour. The rain slowed for a day but continued to rain the following three days. It was estimated that the total exceeded 11 inches! Findlay was cut off from the state. They didn't realize yet that the entire region and states were experiencing the same flooding. A police captain, Bet McGown, lost his life while saving a couple on East Main Cross Street. Property damaged exceeded $1 million. Many businesses were wiped out due to losses not covered by insurance. This picture is in front of the Davis Block, the first building south of the Courthouse. The men are well dressed and don't seem to be bothered by the water. My guess is that they are officers of the bank and maybe shareholders protecting their investments.

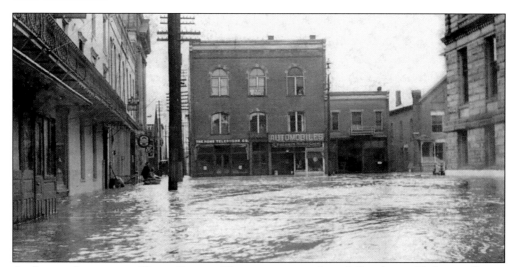

AN IMAGE ALONG THE DAVIS BLOCK. The waters were about 3 feet deep still. A man directs his skiff alongside the wall.

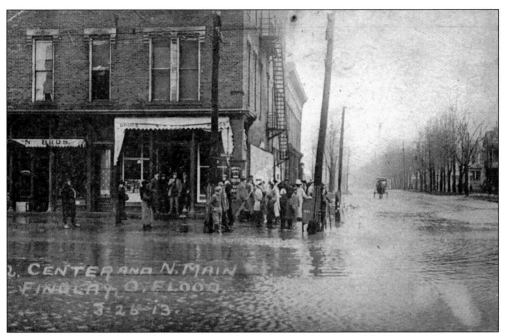

NORTH OF THE BRIDGE. There are not many images of this side of the bridge. This one is of the front of the former Northside Pharmacy. The waters were not as deep here.

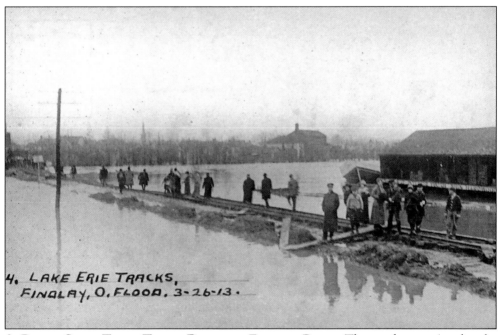

A BRAVE SOUL TOOK THESE PICTURES FROM A BOAT. The tracks running by the lumberyard provided a proper and safe distance above the waters.

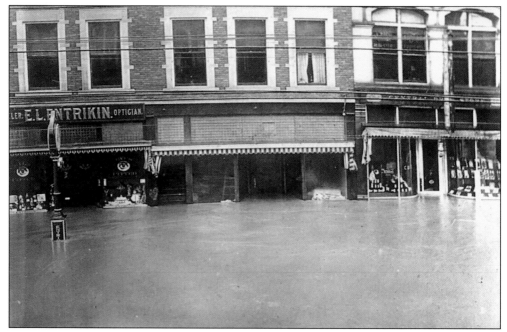

THE WESTSIDE OF THE 400 BLOCK OF SOUTH MAIN STREET. The waters look about 4 feet high.

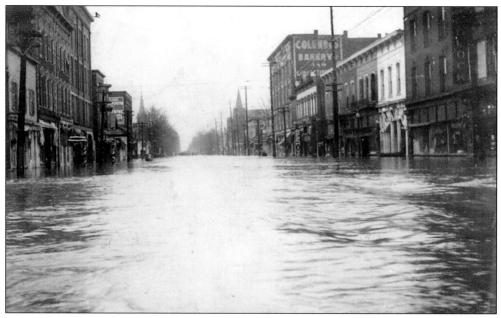

LOOKING SOUTH FROM SANDUSKY AND MAIN STREETS.

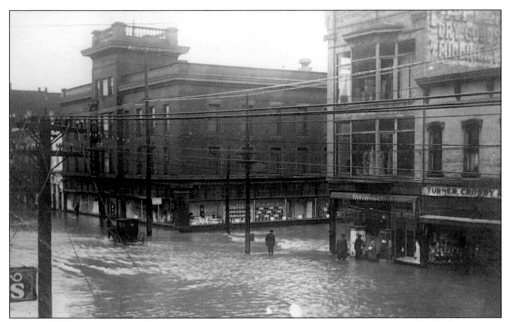

THE GLASS BLOCK AND PATTERSON'S SEEM TO RISE OUT OF THE COLD BLANCHARD RIVER WATERS.

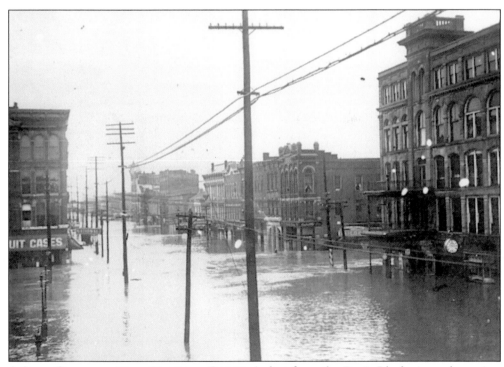

A SAFE, DRY, AND HIGH VANTAGE POINT. A shot from the Davis Block gives a long view of the devastation.

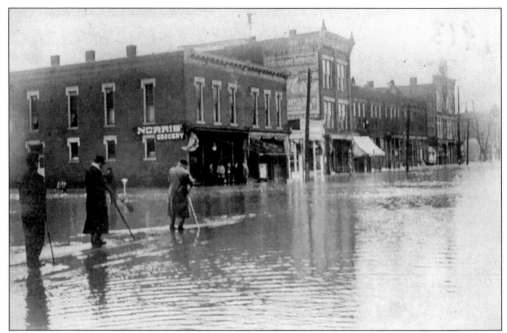

ANOTHER NORTH MAIN STREET IMAGE. The men are walking on the interurban tracks with what appears to be walking sticks for stabilization, checking for open holes!

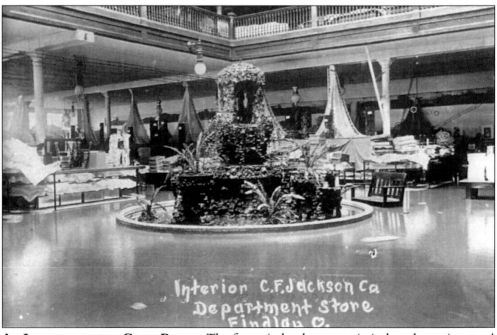

Interior C.F. Jackson Co
Department Store
Findlay O.

AN INTERIOR OF THE GLASS BLOCK. The fountain has less water in it than the entire store!

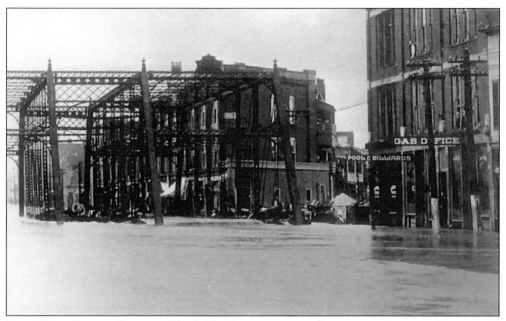

THE MAIN STREET BRIDGE. The bridge became a net of sorts as carriages, outhouses, and other debris jammed in the metal structure.

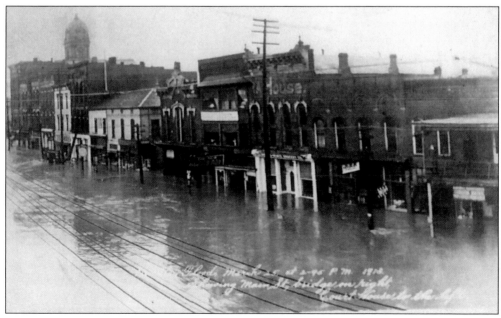

A LONG IMAGE LOOKING FROM THE GREEN TREE TAVERN HEADING SOUTH.

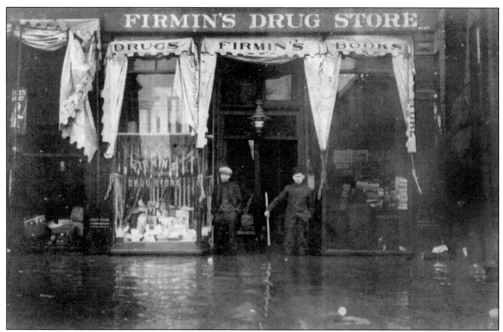

COULD THESE BE GUARDS KEEPING LOOTERS OUT OF THE FIRMIN DRUG STORE?

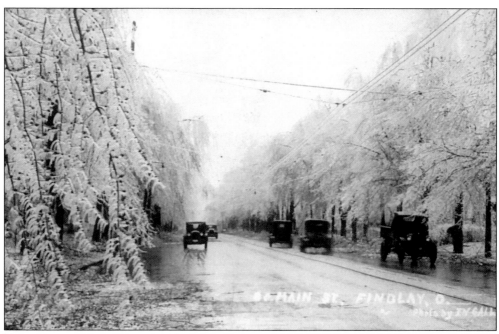

THE AUTHOR SNEAKING IN A PICTURE OF ONE OF THE ICE STORMS THAT HIT IN THE 1920S. I thought you may be too wet and bored with the flood pictures. This was taken during one of the springs of the 1920s, when Nature provided a crystal image of Findlay. Too bad that it destroyed trees and gobbled up power lines, as well as causing panic amongst the general populace!

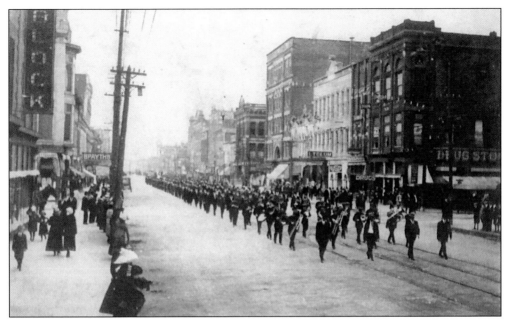

Captain McGown was Honored with a City-Wide Funeral. The procession was several miles long. A fitting honor for a civil servant who lost his life in the course of saving others.

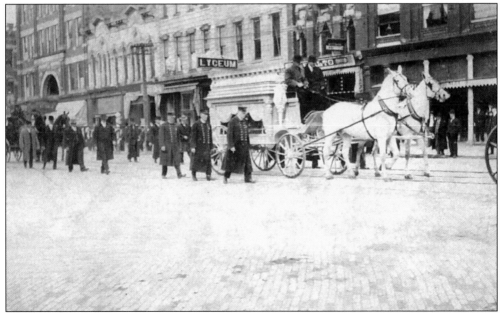

A White Hearse Carries Captain McGown in Front of the East side of the 400 Block of South Main Street. They had to wait several days until the floodwaters had subsided before the funeral could go forward.

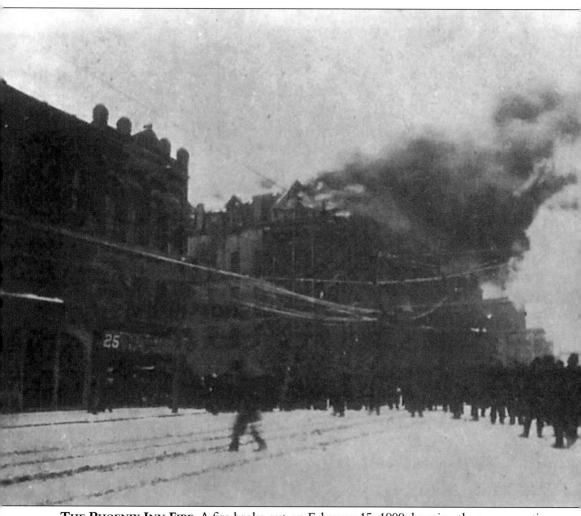

THE PHOENIX INN FIRE. A fire broke out on February 15, 1909, burning the upper portion of the Phoenix Inn. As you can see, people braved the elements to gawk at the fire. The fire altered the roofline and interior of the Inn

Ten

EDUCATION

*W*ithout education society would fail miserably. Learning and the desire to learn creates a more productive and progressive population of citizens. Early in Findlay's history, education was important. With the first "permanent" school being built on the present site of the Armory, education in the mid-1800s became a force in Findlay's growth. Even today, families tend to locate to cities with proven schools and positive educators.

 Early school boards saw the need to expand the educational horizons and started building larger and better-equipped schools. These ranged from Old Number Nine, which was built in 1868 and stood on the northeast corner of East Sandusky, to the junior highs and high schools which soon followed. The bulk of the schools were built in the past 75 years and are being remodeled to keep up the global pace and competitiveness in the education system today.

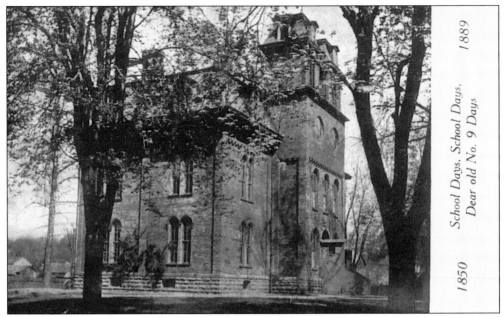

School Days. School Days.
Dear old No. 9 Days

1889

1850

A POSTCARD BEING SENT OUT TO THOSE WHO HAD ATTENDED OLD NUMBER NINE SCHOOL. The school stood on the north corner of East and East Sandusky Streets. It was completed in 1868 and was tore down when a new high school was built on West Main Cross. The bricks were recycled by the Kirk family, who purchased the property. A portion of the foundation is incorporated into the building directly east of the old site.

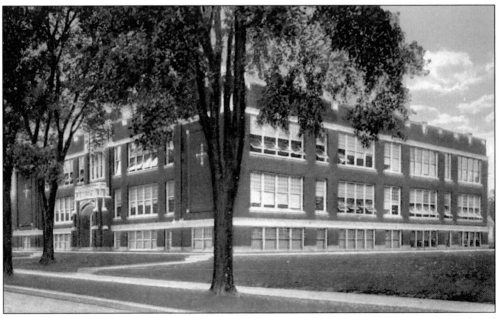

ONE OF THE NEW ELEMENTARY SCHOOLS BUILT IN 1916, LINCOLN SCHOOL. It replaced the old Gray school that stood in its place.

A 1938 IMAGE OF THE HIGH SCHOOL FROM SOUTH WEST LOOKING EAST.

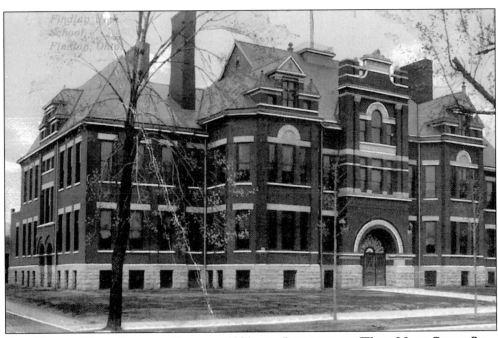

THE NEWEST HIGH SCHOOL, BUILT IN 1901 AND LOCATED ON WEST MAIN CROSS ST.

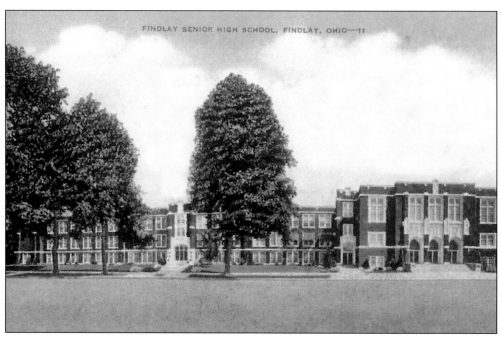

THE CAPTION ON THIS CARD READS, "FINDLAY IS JUSTLY PROUD OF THIS BUILDING . . . "

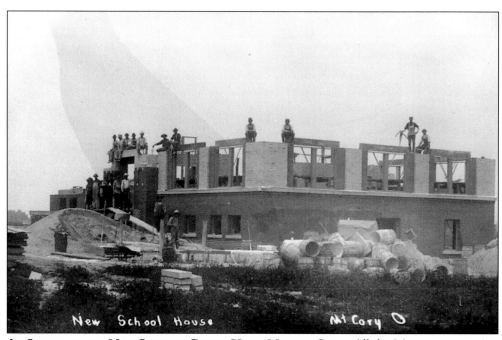

AN IMAGE OF THE NEW SCHOOL GOING UP IN MOUNT CORY. All the Masons are wearing straw hats.

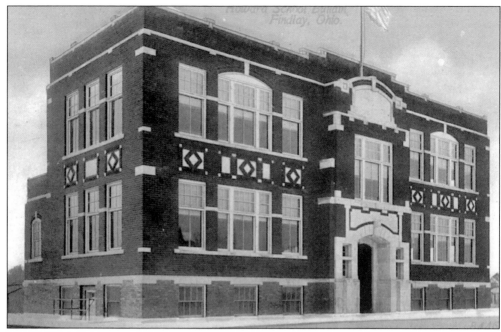

THE SECOND HOWARD SCHOOL LOCATED ON HOWARD STREET. The building was appropriately named after named after Capt. Sam Howard who donated the land. 1911 image

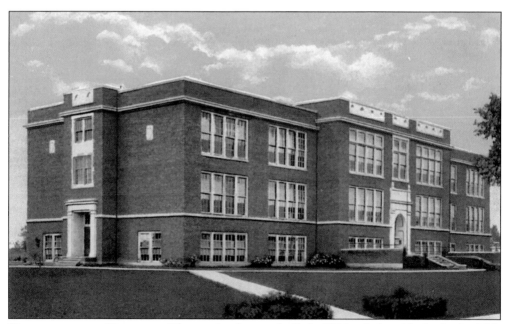

GLENWOOD AND DONNELL. These schools were built in 1926 to help with the junior high school system. Glenwood was finished first at a cost of $150,000. 1927 image

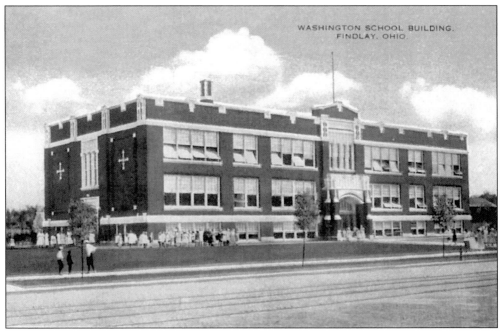

WASHINGTON ELEMENTARY. This school was built on the old site of the Chicago Business Block. 1916 vintage.

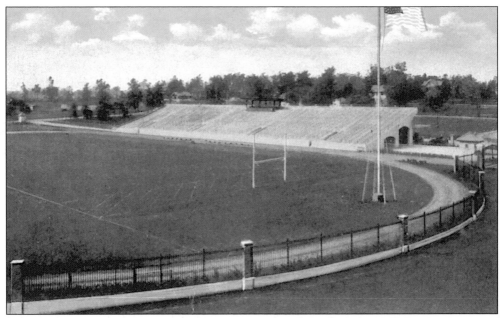

BEAUTIFUL DONNELL STADIUM. The stadium was constructed in 1927–28. It was one of many gifts from the Donnell family. It was made entirely of concrete, and cost $30,000 to build. The pond, strolling park, and tennis courts were also part of the plan to enhance the football stadium.

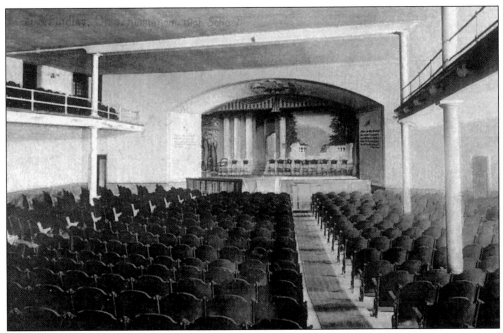

AN INTERIOR OF THE HIGH SCHOOL AUDITORIUM TAKEN IN 1925.

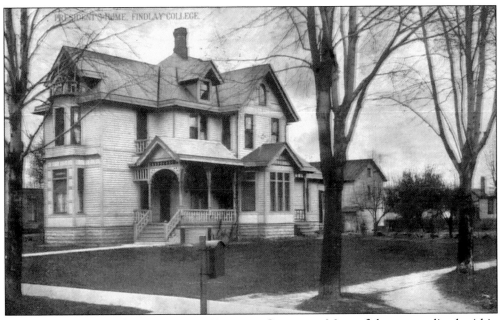

ONE OF THE MANY PRESIDENTS OF FINDLAY COLLEGE. Most of them were lived within walking distance of the college. 1910 image.

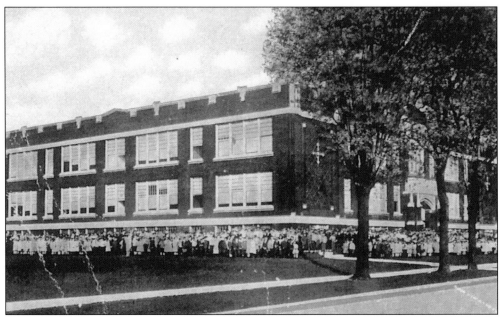

STAFF, TEACHER, AND STUDENTS. The crowd poses for opening day at Lincoln School. 1916 vintage.

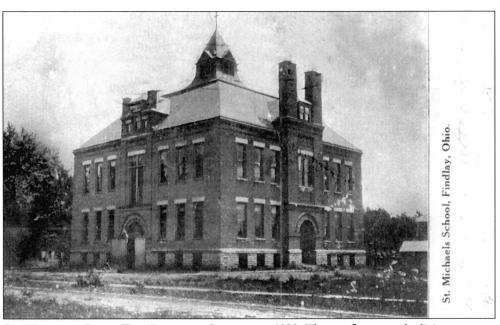

St. Michaels School, Findlay, Ohio.

ST. MICHAELS BUILT THIS IMPOSING SCHOOL IN 1893. The top floor was the living quarters for the nuns who taught school there for close to 80 years. The top was removed later on.

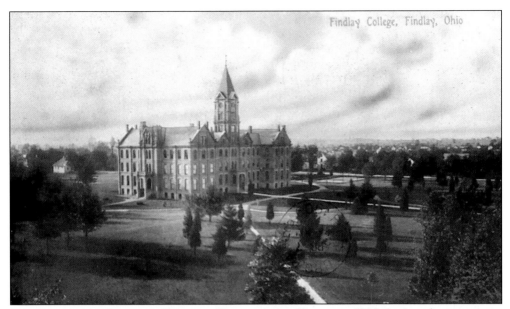

THIS IMPRESSIVE IMAGE OF FINDLAY COLLEGE WAS TAKEN IN 1909. It gives the appearance of success with all of the available ground around it. The University wishes that many more acres had been purchased, as their enrollment is closing in on 4,000.

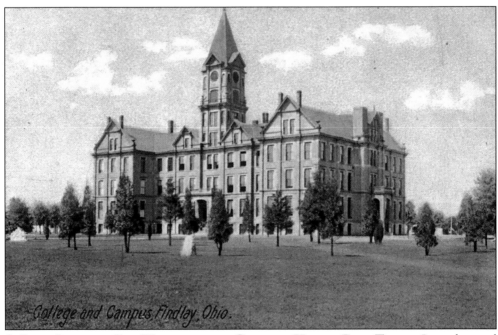

A GOOD IMAGE OF OLD MAIN WITH THE ORIGINAL HIGHER BELL TOWER. It was lowered after it was damaged by fire.

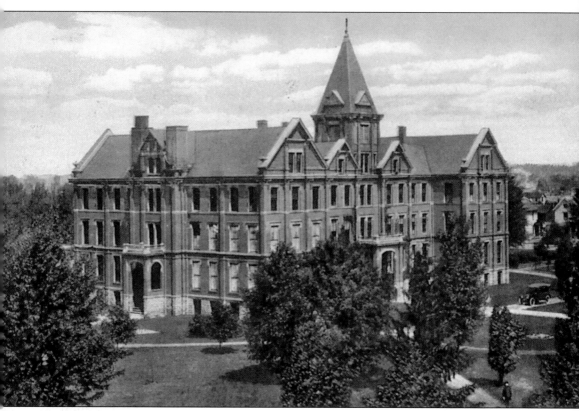

THE TREES ENHANCE THIS MATURE IMAGE TAKEN IN THE 1900S. Many of the trees have been removed.

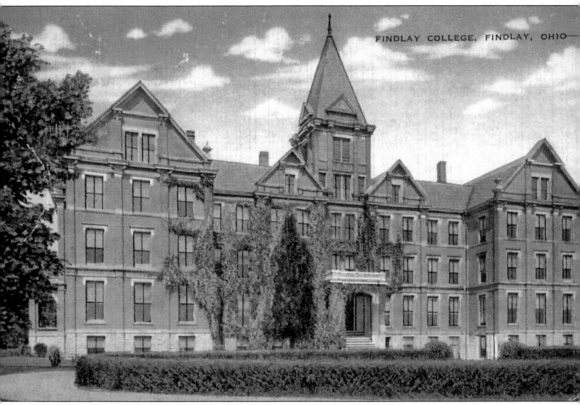

COULD IT BE AN IVY LEAGUE SCHOOL? Look at the ivy creeping up on Old Main! This image is from 1948.

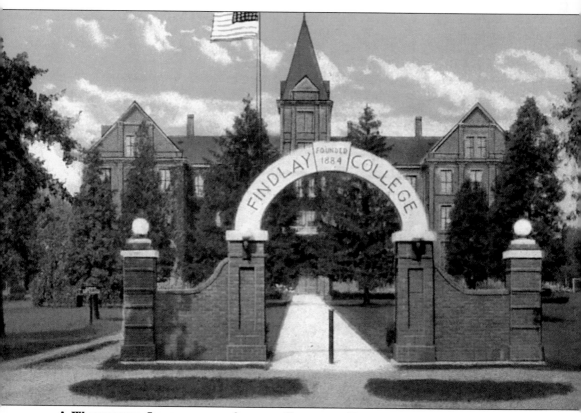

A WONDERFUL IMAGE OF THE ARCHED GATE AND ENTRANCE TO OLD MAIN AND THE CAMPUS. Given as a gift from one of the graduation classes, this archway has developed a tradition. Freshmen who are entering must first pass through the gate; upon graduation the seniors pass out the gate into the "real world!"